Landscape Painting

Landscape Painting

John O'Connor

Studio Vista · London

Watson-Guptill Publications · New York

To J.M.W.T.

© John O'Connor 1967
Published 1967 by Studio Vista Limited
Blue Star House, Highgate Hill, London N.19
SBN: 289 27929 1
Published 1968 by Watson-Guptill Publications
165 West 46th Street, New York
Library of Congress Catalog Card Number 68-10228
Distributed in Canada by General Publishing Co. Limited
30 Lesmill Road, Don Mills, Toronto, Ontario
Set in 11 on 12 pt Baskerville
Made and printed in Great Britain by W. S. Cowell Limited
at The Butter Market, Ipswich, Suffolk

Contents

Acknowledgements

The author and publishers are grateful to the following for permission to reproduce paintings: to the National Gallery for plates 2, 19, 20, 21, 22, 23; to the Tate Gallery for plates 4, 28, 33, 34, 36; to the British Museum for plate 3; to the Victoria and Albert Museum for plates 1 and 35; to the Royal Academy of Arts for plate 24. Edward Bawden's Irish landscape is in a private collection, and Mondrian's *Tower at Westkappelle* is in the Nieuwenhuizen Segaar Gallery, The Hague.

The photographs of landscape 'on location' are by Jane Elam.

Introduction

It is natural that man should wish to describe some aspects of the place in which he lives – the appearance of land and water – and that he should be fascinated by the elements which keep him alive. The earliest known cave paintings are mostly of animals and dead enemies, but in these paintings the rock wall itself and the spaces between the animals and humans are left blank, as the only representation of the land and all its complications. It was a long time before man could relax sufficiently to paint the landscape around him, although it is significant that the sun and moon, as life-ordering deities, appear in some of the earliest known paintings.

We can assume that we have changed a good deal over a period of many thousands of years, but that the sun, moon, rocks, rivers and sea have not. Fortunately, it still rains and freezes and the wind still blows; our copy is omnipresent and inescapable; in fact, the use of the word 'copy' seems almost impertinent, considering that it has been in existence for so much longer than we have.

This book is written for the artist who wants to paint some aspect of his natural environment, and to evolve his own personally satisfying way of doing so. It is addressed to the reader who has already had some experience in painting, who wishes to enlarge his experience and, in so doing, to step aside for a while and reassess objectively his own attitude towards the painting of landscape.

His materials and methods of working will be discussed, together with the manner of producing the completed painting or series of paintings. We will be looking at the way in which other artists have approached the problems associated with this type of work and considering the measure of their success in overcoming them.

There will also be an opportunity to determine the character of a painting described only in words, and the reader may like to use this word picture as a starting point for a painting.

In order to be able to talk about land without going out of doors, a number of photographs and diagrams based on the photographs have been included in the text.

We shall see that a landscape which at first may appear uninteresting can, by survey and careful probing, prove a rich source of painting material. Conversely, a 'picturesque' landscape, apparently almost a ready-made painting location, can give rise to dull and unpleasing work if it does not strike a personal note in the artist.

We shall examine the effect on a generally unexciting location when it is fused with an element of 'drama' – when storm, dawn, sunset or new and unexpected lighting have influenced the physical as well as the emotional appearance of the landscape.

Add to these conditions the factors of changing hazards underfoot or overhead, of noise or movement, and it will be realized that there is more to the business of landscape painting than sitting down with even the most carefully chosen working gear at our side. Disappointment may also result if one is not fully prepared emotionally and intellectually for the occasion.

Some readers will already have many of the smaller problems under control, and will be organized in outdoor working or studio conditions. To them, these essays should offer at least a confirmation of their ideas. On the other hand there are so many aspects of the work to consider that there may be some matters which have not occurred in their experience to date.

The painter may sit on the edge of a forest looking into the interior and probing into the tunnels between the trees, or he may turn his back on the forest and look out over the expanse of the plain. In both cases, his purpose will be to make something personal out of what he sees.

As we shall see later in this text, when whole tree branches bend and sway in the wind and clouds blot out or release the sun, new and very different forces come into conflict with the scheme of natural observation. Later, these forces will be observed to such effect that the painter will unconsciously become something of a naturalist, noting the movement of cool air before a storm, the passage of smoke or dust, and the cycle and development of a day. Moreover, these natural phenomena will become part of his understanding of the place he has chosen to make the subject of his paintings.

The plural here is deliberate, for a great deal of the release and pleasure of such work is lost to artists who attempt to deal with a chosen subject at one sitting and are not able to follow through a series of drawings or paintings on the same theme.

For 'naturalist' in the above statement, we could substitute 'scientist' or 'engineer'; the painter who uses industrial plant and construction as a starting point in his scheme of work will become as familiar with the working routine of plant and factory as the painter of rural landscape does with his subject matter.

The painter will soon learn to appreciate and to clarify for his own use the transformation of a hitherto familiar landscape which occurs through new building or engineering projects on the site. A Gothic castle, a thirteenth-century cathedral or abbey church, a Buddhist temple or a Greek shrine would have appeared as emotionally disturbing in their environments as a pylon, a rig, or a 300-foot cooling tower in the late twentieth century.

The topographical landscape painters of the eighteenth century and the official artists attached to expeditions of the nineteenth century had a special duty to their sponsors; it was their job to return to base with useful, accurate information about the setting of the expedition. Naturally, and sometimes unfortunately, this would be carried out in the working style of the artist himself and that to which his sponsors were accustomed.

In this way some of the best developments in landscape painting came about when artists were commissioned by private companies to draw and paint for them. Their work was generally better than that of the dilettante Grand Tour gentlemen, who drew in the peculiar fashion of the day.

A study of the paintings produced during the two World Wars by official war artists will show that they form a landmark in artistic experience. No one seemed to have had the courage to paint battered land as Paul Nash did in 1916, nor had many burned towns received attention from painters, apart from isolated works such as Turner's *Burning of the Houses of Parliament* and Bruegel's burning land in *The Triumph of Death*, until several artists painted burning cities in 1942–44.

Whereas in 1916 and 1944 there was the film camera to record a great deal of activity, none existed at the Battle of Waterloo or in the Crimea, and the painter in his camp behind the battle carefully drew lines of cavalry and fortifications with

appropriate puffs of smoke over the gunners, only rarely with any sense of creative design in mind.

The painter of landscape who is working for his own satisfaction or in the urgency of his creative energy has no external briefing and should adopt as personal an attitude as he can for the job. A well-known image may be shattered by another artist's interpretation of it, or the awareness of it may be much enlarged. It will be regarded with a new consciousness; the painter should, therefore, try to dismiss this preconceived image from his vision.

Many bad paintings have been produced simply because an artist feels he *ought* to paint a well-known place, or because it 'would be nice' to have a recognizable picture of it. Paradoxically the primitive aim of recording a known and loved place may produce an excellent picture which is both personal and aesthetically positive.

These are some of the problems which the painter will have to solve and which only *he* can solve, but, fortunately for him, there are a great number of ways of achieving his aim and each artist can choose the methods which he finds most rewarding.

1 · Various approaches to landscape painting

It might at first seem obvious that any landscape painting is an attempt to record or portray selectively an actual scene from nature. But though this is more often true than not, the point of origin of the picture – the very reason for its existence – is not always the artist's first sight of the land itself. There are, for example, a number of famous paintings which are in every respect fine landscapes, with all the best qualities of work painted direct from nature, but whose origin is a written source or statement. This applies to paintings of the past several hundred years, and includes all those hundreds of paintings originating from religious patronage and intended to extend religious thought and beliefs for the established churches of Christendom. These are partly moral or 'teaching' pictures and partly portrayals of legend and saintly history, and a large number of our great landscape paintings are to be found amongst them. Yet landscape is being used here only as a setting for a narrative or allegory.

PAINTING FROM AN INDIRECT SOURCE

Two pictures reproduced in this book illustrate this point in different ways. They are *The Martyrdom of St Sebastian* by Pollaiuolo in the National Gallery, London (pl 2), and a small watercolour on vellum by Albrecht Dürer from the British Museum, London (pl 3). They were painted at about the same time, in the fifteenth century, and may be fairly said to represent the approach of many painters of their generation. Let us look separately at the landscape qualities of each.

In Pollaiuolo's picture the landscape is a complete report of an area with which the artist was familiar, but which almost certainly never existed in nature in the form in which he painted it. It is a report presented with powerful artistry. We are given an accurate statement of the river winding through meadows which could be flooded at the weir and rocky falls. The edge of the river bank with poplar and fir trees is timeless in spirit, and having studied the picture we could walk with full knowledge of the ground across most of the low, hill-bordered valley. This zone of the picture is, of course, merely the setting for the martyrdom, but in the planning and painting of it the artist has carefully observed the structure of the valley and rocks, in order to provide both a landscape we can believe in, and one that helps to intensify the savage image of the act of execution. Pollaiuolo's obvious pleasure in drawing and painting male figures accurately leads us also to suppose that the style and nakedness of the painting deliberately reflect and emphasize his strong personal feelings about the martyrdom. In his portrayal of the arch and architectural features beside the mounted officials, as well as in the actual river landscape, he has used his utmost skill to provide a quiet natural setting as a stage for a violent human act.

It is interesting to study the sketchbooks of an artist such as Pollaiuolo, to see how he assembled the topographical or natural facts he needed for a landscape such as this. Facts which he could not obtain from the work of earlier, more travelled artists would be gathered on location by direct personal drawings – probably of various

scenes or features in similar areas. In the final painting, which would be done in the artist's studio, these notes would be a valuable source of information. Their function was to help to create the landscape setting of this and other narrative pictures.

The second illustration, Dürer's small watercolour, *The House by the Pond*, served as just such a sketch for the landscape setting of the artist's later engraving *The Virgin by the Lake*. Yet, far from being merely a study for another picture, this is a complete work of art in itself. Notice the painting of the sky, which, incidentally, could have been painted in our own decade. Notice also the irregular angle of the more positive items in the foreground, such as the boat and the reeds; they are apparently drawn with a casual sweep of the hand, but are in fact made with the care and confidence of an artist later to become a most skilled draughtsman and engraver.

This method of landscape painting from an indirect source can be quite a rewarding exercise for the present-day artist, if we remember that a source of this kind is not in itself selective; we can only make ourselves receptive to it and then make what we can of it.

IMAGINARY LANDSCAPES

It is necessary to attune oneself to the possibility of reading or hearing something that may suggest a landscape painting and, whenever one is alerted by such a suggestion, to explore it further. Obviously not all suggestions will finally prove valid or lead to good results. Obviously, too, those are most likely to be influential (for good or ill) that come at a time when no visual factor can weaken or counter-influence the intensity of the mental image – indoors at night, for example, or 16,000 feet above a known but cloud-concealed territory. Extreme examples of landscapes evolved in this way – presenting entirely imagined land forms – are the 'jungle' settings of Le Douanier Rousseau's pictures of wild beasts; his only visual influences were the potted palms in the Jardin des Plantes in Paris, many thousands of miles from the tropics.

It is true, of course, that all good landscape paintings (including those painted direct from nature) have something of this in common; all must pass through the selective processes of the artist's imagination and may contain certain 'invented' features. But we are discussing here the deliberate exclusion of any new material from the visible world around us, so that the land of the dream and of the mind can come forward uninhibited. The point of origin may be a biblical story, a memory, a photograph, a piece of verse or music – anything other than the real land in front of us.

Let us suppose that we hear from a friend in a foreign country of which we have some slight knowledge, perhaps from photographs or descriptions of it seen or read many years ago. However good we are at visualizing from this information, the picture we create in our minds is inevitably remote from the colour, light, air and environment of the real place. Nonetheless, this picture may be very paintable, possibly poetic and aesthetically sound. It is personal, artistically original and honest, and thus in some ways more real than the real place we do not know.

Painting landscapes entirely from one's imagination has its own dangers as well as difficulties. Perhaps the greatest danger is that the imagination, living off itself, so to speak, may become devitalized and moribund. The painters of the more academic institutions in France and America during the nineteenth century, who

developed their own imagery within this kind of framework, produced a number of masterpieces, but also some indifferent work. However, this form of approach can be a good exercise for the landscape painter who has not yet tried it, if he accepts that there are numerous pitfalls awaiting the unwary, and several unsatisfactory efforts may be necessary to clear the experimental stages. Beware of repeating a certain image or device too often because it has proved pleasing or easy, and avoid a great deal of trivial, invented colour which may detract from the power of the design. (See notes on a limited colour palette p 87.)

The origin of a picture conceived in this way may be simple or complicated. Sometimes an experienced artist can visualize the whole landscape image after listening carefully to a piece of music or reading a descriptive passage in prose or verse. The kind of painting which results will border on the field of illustration, and there is no reason why this should not be so. Though the first spark of the idea will have come from the words or music, this will provide only a starting point for an additional or parallel image that may be quite different in emphasis or approach and yet be equally valid, sometimes even exceeding the original in aesthetic content. Turner's painting, *Hero and Leander*, in the National Gallery, London, loses something of the drama of the battle against the waves as described in Marlowe's poem, in the process of becoming a large and intensely experienced sea-landscape painting.

DANGERS OF TECHNICAL FLUENCY

The landscape painter who alerts himself to many different kinds of inspiration must take special care that his own technical efficiency does not get in the way of certain facts and feelings he wants to convey. Technical proficiency is, of course, necessary; any artist must use a recognizable 'language' for what he wants to say in paint, and must master this to a reasonable extent during his development. But it is easy to get to a stage where one's fluency in the use of paint – especially in one's own semi-mastered style – hinders the honest communication of a particular impression or experience. There may also be occasions when it is necessary for parts of a painting to be allowed to remain inactive in order to put over a certain mood or atmosphere. Some of the artist's facts or feelings are sharp, hard-edged and clearly defined; these need a similar well-cut treatment in terms of paint. Others, just as valid, and often part of the same total experience, require a less self-conscious and uninhibited treatment if they are to be presented with power and conviction. These different treatments, like the different emotions they convey, are not alien to each other, and may co-exist successfully in the same picture, as in Chagall's large group of paintings of lovers and families in streets and landscapes.

A piece of landscape might also be seen to have much in common with a work of free-standing sculpture which accepts whatever is visible behind, below and above it. The width and depth of the land present a formidable problem to the painter, yet any landscape has to receive some imposed margin or limit if a painting is to be developed from it. It is more important that a complete area should be taken at its own value, and seen in relation to its own weight, light, movement and volume, than that it should be cut, edged and festooned around with marginal accessories such as trees, tall plants or objects nearby, in order to make a contrived picture or design. Moreover, the shape of a feature in a landscape – whether it is sculpture made by man, or a piece of natural rock, flowing water, or a hedgerow full of flowering grasses – is no less acceptable if it is irregular; there is little point in prettifying or regularizing it for the sake of the design.

2 · Materials and equipment; some problems of working out of doors

As we are thinking in this book of a particular field of painting, there is no point in providing a full account of the business of planning a studio, or of the technology of painting and the handling of equipment and materials. The reader will find good accounts of these matters in several books, some of the best of which are listed in the bibliography. He may already have some knowledge of paint and made his own personal choice of colours. There are, however, certain points about painting or drawing out of doors and the preparation of work for the studio which it would be helpful to explore, and which do not usually appear in manuals and textbooks.

Let us consider these points under the following headings:

1 Pigments and coloured inks
2 Papers, boards and other surfaces for working; the use of trade and printing papers
3 Experiments with paper and media
4 Easels and accessories
5 Carrying of materials
6 Working conditions: some problems.

PIGMENTS AND COLOURED INKS

The media most likely to be used by the painter will be found among the following:

Oil paint

This medium is best purchased in tubes for occasional outdoor use (though larger tins of paint manufactured for the trade can be used quite satisfactorily in the studio although this tends to be impermanent). Studio-size tubes of artists' oil paint should be used for primary colours – yellows, reds and blues – and the largest size for white; if required small tubes should be used for such colours as cobalt violet, orange vermilion, cadmium orange, cerulean blue, Naples yellow, terre vert and so on. Enquiries should be made at the dealers' about comparative prices of little-used colours. Some, such as orange vermilion, are expensive.

It is important to remember that oil paints and oils should be kept in a separate container, away from non-oil paints.

Acrylic paint

Most acrylic paint is used with water as a medium; it is produced by the trade in about thirty colours and tints. The principal colours should be selected as for oil paint, according to one's particular need. Acrylic paint is similar to gouache in many respects, and may be used in its thick, solid form or diluted. Remember to wash all brushes used with this paint in clean water; otherwise they will become unfit for further use, as speed and permanence of drying is one of the important properties of acrylic paints.

Gouache (opaque watercolour)

This is supplied by the trade as 'designers' colours' in tubes. These are larger than standard watercolour tubes, but not as big as studio-size oil tubes. It is also supplied in screw-top jars in one or two sizes. It has an opaque consistency but retains a brilliance when dry. The consistency varies with the colour, but all colours are pasty like very soft putty. It is important to wash brushes regularly when using gouache in conjunction with watercolour (as one might do out of doors) since the body in gouache will impair the clarity of any watercolour in use at the same time. Otherwise, gouache and watercolour may be mixed safely and satisfactorily, if one remembers that once gouache paint has made a surface a pale watercolour will be reduced in power if used for working over it.

Watercolour

This has been considered essentially an English and American medium, especially since the eighteenth century. It is, in fact, very suitable for the wet climate of Great Britain and the humid north-eastern United States, although it is adaptable to most climates. In very warm temperatures one can use it so long as liquid is available, and it is also possible to manage even if ice settles on the brush and on the palette in several degrees of frost.

The pigment may be used very easily in the form of dry cakes or sticks, but on location it is a hindrance to rub from dry colour blocks. Tubes are in many ways best. Pigment may be spread on to the dry paper and worked with a water-loaded brush, or the palest and most delicate tint of colour may be applied from a smear on the palette mixed with plenty of water.

Miracles should not be expected of watercolour, and the limitations of each artist will find him out quicker than he realizes.

Prices of watercolours vary a little between tints. The choice of colour is almost the same as for oil paint, although generally a wider range is available; for example, among the many colours supplied by the trade (and often neglected) are Hooker's light and dark green, and Davies grey (a delicate tint).

It is reasonable to carry about twelve colours. A suggested choice might be: in *yellows*, cadmium, lemon, yellow ochre (not gamboge, which is demanding and will probably spoil other colour schemes); in *blues*, ultramarine, French blue, cerulean, and, in very small quantities, Prussian blue; in *reds*, madder or alizarin, cadmium red, cadmium orange, Indian red; and in *additional colours*, pale browns, greens, purple and white (gouache white is well suited to mixing with watercolour paint).

Of all media, watercolour is the easiest to transport, although a little time should be allowed if possible before packing after work.

Coloured inks

These are generally prepared in two varieties: waterproof and non-waterproof. They should never be mixed unless in experienced hands, since waterproof ink dries quickly and permanently, and is, of course, not again soluble.

Unless he is working in flat areas of colour, which are impersonal in character, a painter may prefer non-waterproof inks because they can be diluted easily and may be used on almost any surface that is not too glossy or oily. Their permanency is variable, and trade catalogues should be consulted on this point – as of course they should be when buying any type of paint.

Chinese ink, obtainable in stick form, is prepared by Winsor and Newton in

bottles and will mix well with any other water-bound material; when using these inks, however, great care must be taken to wash brushes thoroughly, as a favourite brush used for some heavier ink will become rather gritty and unusable for water-colour ink.

PAPERS AND BOARDS AND OTHER SURFACES FOR WORKING:
THE USE OF TRADE AND PRINTING PAPERS

We assume that, for oil painting, the artist who is using canvas will have already decided which type suits him best; light-weight, heavy-weight, rough or smooth. There is a much greater choice among papers. Moreover, information about paper is more difficult, and sometimes impossible, to obtain from handbooks dealing with painting techniques or from dealers' lists and catalogues.

Nevertheless, the selection of a suitable paper is most important, and every painter needs to experiment to find those which suit him best. It is not uncommon for an inexperienced artist to set off happily on a painting holiday, only to find himself in a remote area with a stock of paper entirely unsuited for use in that environment.

It is a good thing to experiment widely with rough papers with irregular surfaces which greedily absorb water or oil, and will not crack if handled reasonably, and those tempting light-weight papers which offer rapid absorption but will not stand the strain of drawing with a pencil or the more violent use of brushes. It is true that sometimes an unsatisfactory paper and medium will encourage an artist to produce a more virile drawing through the need to record the occasion. A sun behind a mountain will be no less remembered for being noted in sticky mud or scratched with a bent nail on a piece of cardboard.

A good, reliable paper is not an easy thing to acquire. Some stocks of old paper exist, and dealers will offer a variety of watercolour papers. Compared with canvas, paper is not expensive, allowing for the fact that no stretcher is required. Buying the best paper should not be regarded as an extravagance: it must be reasonably expensive to be any good at all, and a paper upon which several hours of work may be made is worth a modest investment.

Papers can only be proved by trial and error. One can choose between soft and hard papers, i.e. those with a soft size content which will absorb moisture quickly (the extreme is blotting paper) and those which are hard-sized and pressed in machine rollers to give a hard, smooth surface which will absorb moisture slowly, (super-calendered [shiny] papers are the extreme).

Other papers suitable for sketching are:

Ingres

Manufactured in white or pale tones (these are likely to modify paint colours slightly) with a reasonably quick absorption. It can be stretched easily by damping on a board with gummed or taped-down edges. The American Strathmore is similar.

Michallet

A little tougher than Ingres, otherwise similar. It shows machine lines on the surface from drying racks during manufacture; these can be attractive.

Cartridge or white drawing paper

Produced in many qualities. It is white and strong but cheaper grades will fade and

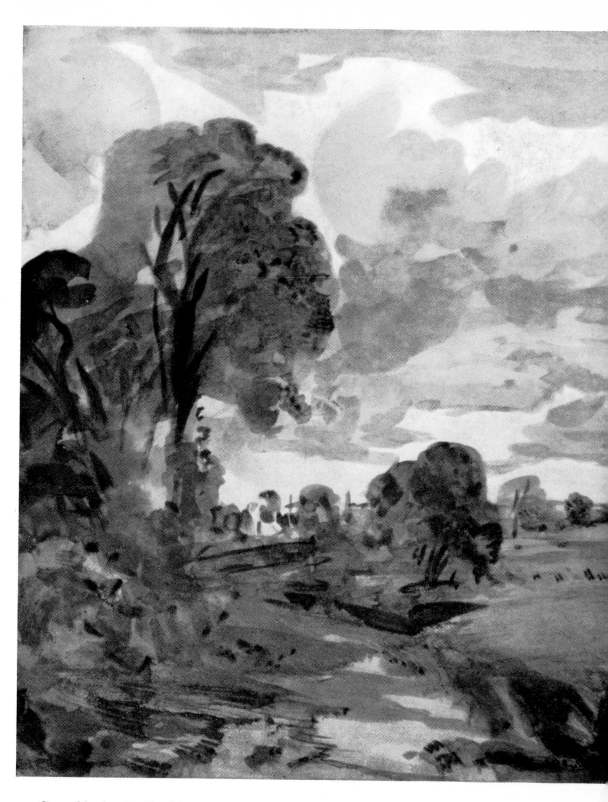

1 Constable sketch – English landscape

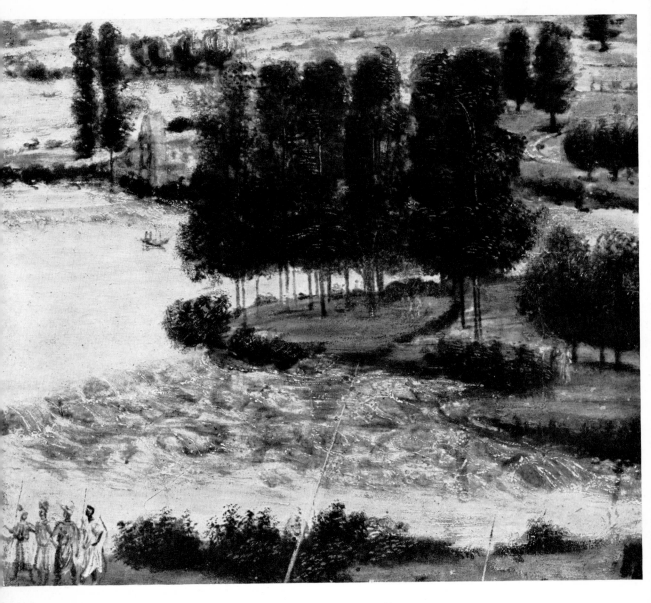

2 *The Martyrdom of St Sebastian*, Pollaiuolo *(Detail)*

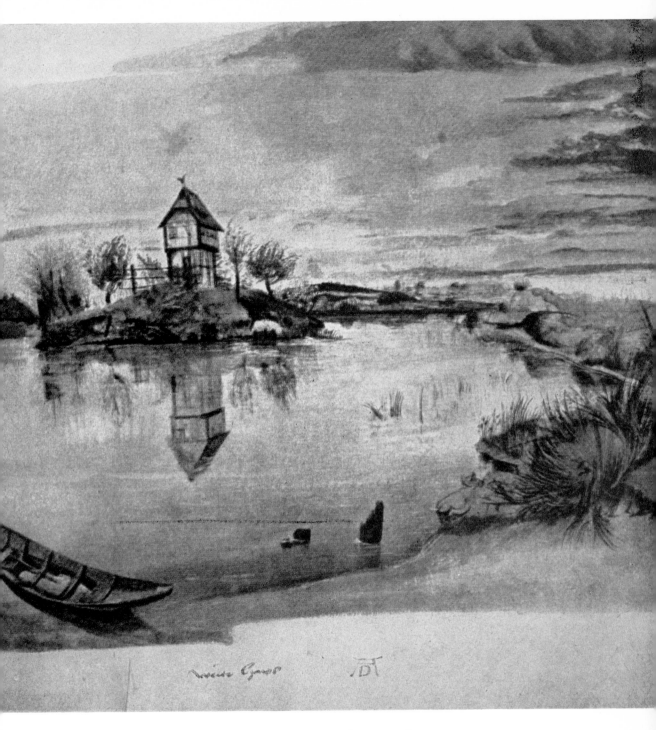

3 *The House by the Pond*, Albrecht Dürer. Watercolour on vellum

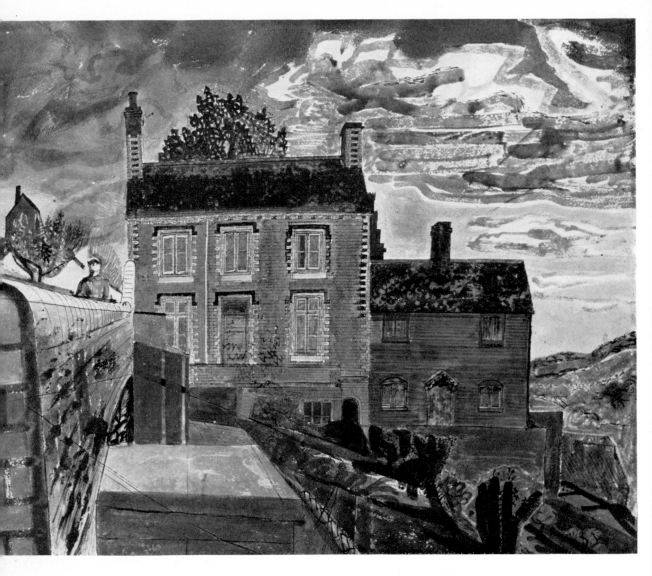

4 *Houses at Ironbridge*, Edward Bawden

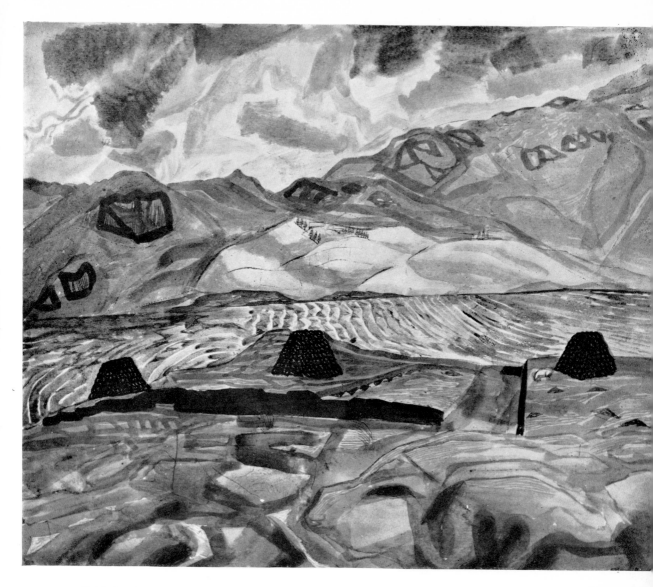

5 Irish landscape, Edward Bawden

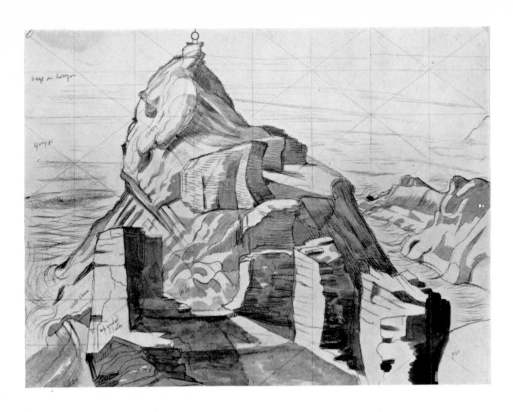

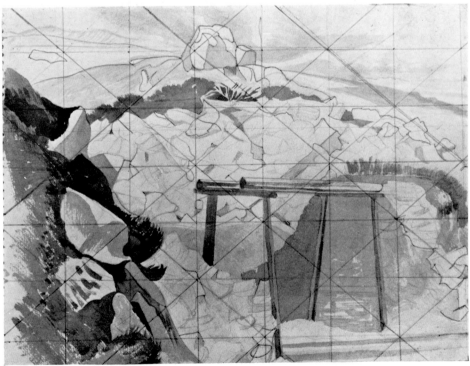

6, 7 Two sketches of Cornish mine workings, squared for enlargement, John Nash

8 Paper between board in waterproof bag, with painting box, gouache and watercolour
 equipment

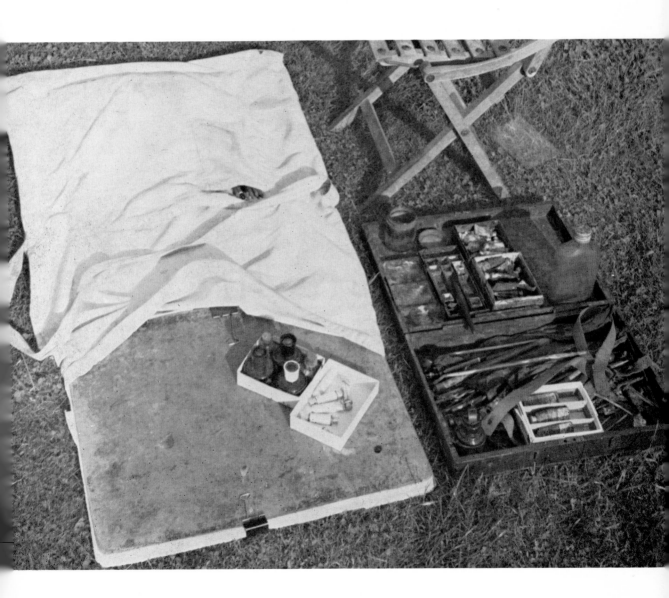

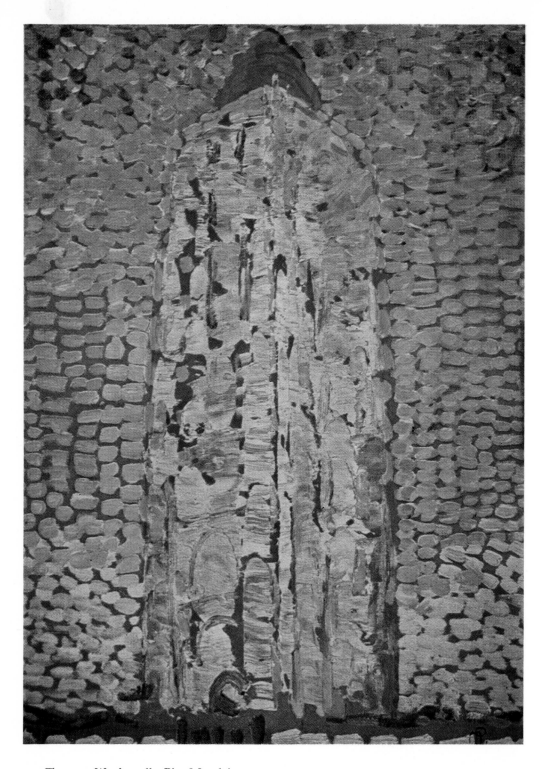

9　*Tower at Westkappelle*, Piet Mondrian

yellow in a short time, especially if exposed to light. Good quality cartridge (drawing) paper is as suitable as any for general purposes. A number of surfaces are obtainable, from smooth to a slightly rough, dry and absorbent surface. If possible, do not roll it, but carry it flat.

Hand-made

This is a top class paper group in 'fine art' work, but the name does not necessarily imply the individual workmanship of the past. A good quality hand-made paper will be strong, fast to light, and available in a number of surfaces, such as:

1 Hot-pressed paper . . . a paper which starts out rough-surfaced, but which has passed through a rolling machine to produce a much smoother, harder surface. It is less rapid in absorption of moisture or medium than untreated paper and is velvety or marble-like to the touch. It has a sensuous surface with some of the qualities of polished wood.

2 A 'not' (rough or cold-pressed) paper . . . a rough-surfaced paper which has not been pressed, and has been allowed to set in a variety of grades of surface. This may be very rough indeed or medium-rough like a piece of dry plaster, and will be reasonably absorbent.

There are several other brands of hand-made papers, and information about these can usually be obtained from dealers in artists' materials, who will say whether or not they are in short supply.

Good papers can be obtained from a number of places. It is a good idea to have a word with a master printer or the department manager of a printing house who may know of a number of papers available to the printing industry which are also very suitable for drawing and painting. Some printing papers used by the trade are especially attractive, and a few notes about them may be helpful. Look for 'wove' papers which are medium soft size. These are excellent for some artists' type of work, for drawing and painting in pencil, chalks, watercolour or gouache. Compared with hand-made papers they are not expensive.

A 'laid' paper, of which there are many varieties, is very good, whether it is an 'antique' or bears any other trade label. They are similar from the artist's point of view. There will generally be lines from the rack of the paper machine on the surface, and the watermark may be quite prominent.

'Parchments' in a trade list are sometimes a little smooth for drawing, but there are some excellent papers in this range. A warning – they can be brittle, and although good for book production, will not remain undamaged in the much larger single sheet size. (A book is rarely larger than a sheet of typing paper.)

Printing trade lithographic or offset paper can be very good for drawing, but should of course be tested and used by the artist before he accepts a large amount of it.

For producing a large version of a picture, an artist would be well advised to use brown (wrapping) paper, which is very good to draw on and which can be obtained in very much larger sizes than white paper.

It is as well to avoid all papers with specially prepared surfaces, such as imitation vellums or leather-textured papers as, with this excessive texture, they tend to leave watercolour lying about on the surface. Glossy papers are also very difficult to use

without special experience, unless of course one is aiming at the break-up of colour which will result from their use.

Generally, a rough-surfaced paper containing only a little size will absorb a painter's medium extremely quickly. The degree of sizing is important because a rough paper may look tempting on the counter of an art supply shop, but may prove unpleasant to use if, as is sometimes the case with a rough paper, it is hard and non-absorbent. This means slow drying, which may be desirable in some instances, but a running together of colours which were intended to remain independent can be a disadvantage. It is best to be able to handle and even to moisten a paper specimen before choosing, and some dealers will supply a testing sheet for customers. If the size is light, the paper should bend in a gentle curve, and be supple when handled. The presence of a hardening or synthetic material, perfectly suitable for display or printing industry use, would make the paper brittle and unsympathetic.

Once a paper or group of papers has been chosen, it is a good idea to use one or two favourites for a while in order to find out to what extent paper technology helps the painter in the mastering of desired techniques.

It is wise to collect as many types of paper as possible at any time, but do not keep them rolled or in a tube. Tubed paper gains tension in the roll and can become one of the most irritating factors in the whole business of drawing and painting. One method of dealing with tubed paper is to re-roll it gently round a tube in the opposite direction and leave it for several hours before using. The tube should be at least 2 to 3 inches in diameter and inflexible.

This method should not be used for a thick-coated or 'crackable' paper. To flatten such a paper there is a method which is suitable for any paper in stock. Lay the sheets face downwards (the watermark is readable on the right side) on a flat, clean, hard surface which is larger than the paper, so that the edges do not get damaged. Put a second piece of cardboard, or hardboard, of the same size, over this and press with something heavy (books, for example). Most papers will be ready for use in a day or two after this treatment, and should not need drawing pins (thumb tacks), tacks or clips.

It is most important that the paper storage place should be quite dry; paper can be kept in dry conditions for many years without coming to any harm.

Card and board

These are usually bought by the trade in bulk, and it is as well to try to persuade a printer to let one buy a small quantity, a quire (about 20 sheets) or two, or half a ream (300–500 sheets depending on weight) at a time.

Card (fashion board) and board sometimes present difficulties because only good white or permanently toned cardboard should be used. Cheap card (or fashion board) will probably go yellow quickly and crack; also, mildew can form and a glue or paste may appear in texture through the surface. Paste board, or illustration board, then, should be purchased at a good price to assure satisfaction in use.

A card cannot cockle or wrinkle on its surface. This is an advantage, but a good paper need not do so either if it is held down firmly and is not 'springing' before one starts work. 'Illustration' board, 'fashion' board and 'paste' board are trade names for these stronger surfaces. Boards are made in rough, medium or smooth surfaces. An overlay of protective paper may be used to keep the working surface clear in case of friction during movement. This is more likely to occur on board than on paper. Boards are, of course, heavy by comparison.

Here are some notes on testing the properties of papers in a series of interesting experiments.

Tear a sheet of paper into several pieces. This will show if there is a tendency to crack and wrinkle, or if the paper is likely to tear when in use. A good, sturdy paper will tear in the direction in which it is pulled. A cheap, poor quality paper will probably tear in unexpected places, or a piece may literally come away in the hand. The good paper will tear into usable pieces, i.e. the torn sections will not be damaged. Note that Japanese papers, thin or thick, do not come into this test; they are in a category of their own, and form a strong direction of grain in the production process. They will not be of general use to the painter, but should certainly be tested in the more expensive heavier weights in order to assess their special qualities.

Dip pieces of paper into dye, ink or paint, and test their drying qualities. Splash any medium – oil, water, turpentine – over the surface, and again test drying time to see if the colour of the pigment changes much during the drying process. If there is a change it will generally be disappointing; for example, a drawing or painting made in a rich blue and velvety black may dry into a muddy blue-grey and a pale brown. If the pigments have been diluted to excess, they may lose some of their original colour, although in this case, of course, the fault will not be in the paper.

Rewarding results with unexpected brilliance of colour can be obtained by using the cheap 'paint-box' colours sold for children, but even the best quality colours will not last or look well on a cheap or unsuitable paper.

Stretch a sheet of paper (use good sized sheets in all these experiments) over a board, and bind the edges by about half an inch all round with gumstrip (brown paper tape) or Sellotape (Scotch tape). Pour water or a medium over the surface and then dry slowly by sun or artificial heat (a hair-dryer is excellent), and try applying colour at various stages during the drying process. If, for example, a blob of scarlet is allowed to drip off the brush in one or two places, on some papers the colour will remain original in the dry areas, and on others it will change.

It is a good idea to keep notes of these experiments on the paper itself, preferably in a panel left blank for the purpose.

The next test is for durability of surface. Try this on a tough paper, or any strong 'laid' paper. Scratch firmly over the surface with pieces of twig, matchsticks, the ends of brushes or the fingernails. Then wash colour over the surface and see what happens when the colour rides over or settles on to the lines which have been made. This is very nearly a form of engraving on paper, and on some papers the linear design so made will have much of the quality of an aquatint background over an engraved or deeply-bitten etched line. This is not just a technical trick, because there are no rules as to how paper and paint should be used, and the final manner of executing an idea rests entirely with the person involved.

Oil paint on paper

It should be noted here that oil painting on paper either straight from stock or prepared with a wash of size can be a very successful method of working; it is sometimes not fully realized to what extent work can be done in this way, given a good, tough paper and clean paint. To some, this is preferable to the use of a trade 'canvas' paper which has either a woven texture surface, or is artificially made to look like canvas. Paper can be given a tougher surface by dusting a thin layer of sand or chalk on to the wet size or gum medium which has been run lightly over the paper

when stretched. Note – excess or 'pool' medium or size should be taken off with blotting paper before adding other materials.

Acrylic or emulsion water paint may also be used on paper with similar effect. A quality rather like that of gouache may result, because the body in some acrylic colours favours an opacity typical of gouache.

Try dropping oil paint mixed with oil, varnish or turpentine on to an emulsion or water surface. Shake or tease the pigment on to it; in this way one can find out what will happen without damage to separate brushes by contact with the paint surface.

To test pigment, oil or water-bound, it is a good idea to pin specimens of colour, painted on selected surfaces, to the wall of one's workroom, exposing them to light and air for measured periods of time to check for fading.

During the testing of paper and media, it is most likely that the artist will discover much that will be of direct use to him in producing a series of paintings, working either out of doors or in the studio.

EASELS AND ACCESSORIES

Easel

If an easel is to be used for out of door work, it should be light and portable. The trade products are reasonably priced and hard-wearing. Various styles are available at most of the principal dealers. They are illustrated in catalogues and on show in shops. Some school easels are very good, and one should enquire at educational supply firms about their designs and prices. It is important that a folding easel should be fastened in the method prescribed; the sections should not be forced into place.

Stool

A stool is often overlooked, but is sometimes indispensable. It should be of light weight and a folding design (not a collapsing design – there is a subtle difference), and should not be unduly flimsy. A stool with legs, rather than a bent metal rod, as support, is far easier to make stable on uneven ground.

Brushes

Good quality brushes should be used for all media. Art dealers' shops supply a wide range of oil brushes, but watercolour brushes, suitable for gouache, watercolour or ink, tend to be either expensive or inferior in quality. Chinese brushes are strongly recommended for use in watercolour painting, but the directions supplied by the makers must be faithfully observed, i.e. care after use, gentle handling, protection of handles from water. Brushes are best kept in tube containers made of plastic or cardboard; these may be obtained from suppliers, but often similar material may be obtained from draughtsmen's offices and industries associated with printing and office equipment.

Containers

Water for diluting inks and paint and for cleaning is best carried in two containers; one can be used for storage and the other during work. Soft plastic flasks or bottles are excellent for this purpose and are easier to carry about if they are flat rather than tubular in shape. For painters in oil, similar containers with screw tops will be

needed for solvents and medium, i.e. turpentine, linseed oil or varnish, or a wax medium, according to preference.

Palette

Usually, the oil-painting box is supplied with a small palette. This is quite useful, but a larger one may also be required.

Sketch books

It is as well to avoid all sketch books which are made of thick, unfriendly cartridge (heavy drawing paper) or hand-made paper, trimmed and held together by a rubber composition, on a back card of strawboard or grey chipboard. Every drawing on such a block will have to be removed whether completed or not, in order to allow the paper below to be used, and this makes the paper seem unduly precious. A book of leafed paper (preferably with a spiral binding) is very much better for a series of drawings, especially for casual or reporting work. Light-weight paper, bank paper (or thin writing paper), light printing paper are all useful for drawing out of doors.

Pencils

For sketch notes, pencils of HB, 2B or 3B will be quite soft enough for general use. If 4B or 6B are used, the effect will be similar to that of chalk, and in this case working should be as clean as possible in the early stages, as rubbing and general deterioration will eventually occur. If the artist wishes his drawing to remain clean, a protective fixative spray must be used.

Insect repellent

Insects and biting pests usually await the contented painter, and some form of repellent is advisable, particularly on the wrists, face and ankles. If the reader feels sceptical about the necessity for this precaution, one or two occasions of being driven off by flies or mosquitoes will convince him of the value of some protection.

CARRYING OF MATERIALS

Much inconvenience can be avoided if one devises an efficient method of carrying materials on location. As with the golfer and the lepidopterist, it is the load of equipment which one is *not* likely to need which should be carefully considered before setting out. One thing to remember is that location work when using oil paint, for example, is in some measure an expedition, and unless preparations are made beforehand the chances of success are reduced.

Box

A convenient, light-weight box is essential. This should contain the normal equipment of an oil painter; liquid materials should be carried in screw-top bottles, and a safe place should be allowed for the carriage of brushes. Paint tubes should be packed either in boxes of two or three, or in such a way that they will not move about during transport; a piece of rag wrapped round them will keep them secure.

Bag

Plate 8 shows a very simple and effective carrier for ordinary drawing and water-colour materials, as well as for an oil-painting box and accessories. It can be made

of a light parachute nylon or similar tight-meshed waterproof fabric. Plastic is not sufficiently durable. About 1½ yards of material of average width will be sufficient to make a carrier for a drawing board and paper of approximately 22 by 17 inches, but the measurements will, of course, be dictated by the preference of the painter for a particular size of paper or board.

The fabric is folded in two, and one end is left open like a windsock. The flap will then fold over the remaining piece and protect it. One or two pockets can be sewn on the front section and these should be large enough to accommodate additional painting boxes, plastic water containers and notebooks.

An additional narrow pocket is recommended, as shown in the photograph, and this will hold pencils, chalks, etc., and, if desired, a toothbrush, for this painting bag can easily become an overnight bag if one decides to stay on location. It is a good idea to fix a strong, two-inch wide belt of canvas or nylon to the fold of the bag, so that when carried, the open end falls over the face of the board. This gives some protection against impact and can be rolled if necessary in order to keep the bag quite watertight. In the photograph the bag is lying on the ground and the boards are inside it; the position of the strap is clearly seen. This container will protect the contents from damage on damp ground, and, if no other seat or stool is available, one can sit on the folded flap when working.

For oil-painting materials, assuming one has one of the usual painting boxes supplied by the dealers, it is advisable to have another similar bag, to ensure that watercolour equipment is not mixed with them.

Carrying canvases

For carrying drawings and watercolour or gouache work, two equal-sized pieces of hardboard, heavy chipboard, or Dala board from a printer or binder are recommended. These can be held together by clips, preferably of the type which fold over and lie flat on the surface.

A canvas on a stretcher can be carried in the bag before use, but is best carried in a way which separates one painting from another. A bar in which notches have been cut to receive the stretcher width is put at the top and bottom of the canvas or canvases. If necessary, a bar can be put on all four sides of the canvases. Cords should be tied over the clips, so that they remain in place. A handle of the grip-bag type is usually fitted to one of these clips to make carrying easier. Full particulars of this standard type of carrying equipment can be obtained from most dealers in artists' materials. Naturally, it is most convenient to carry the work to a waiting vehicle in which it can be placed flat and face upwards, but it cannot be presumed that the chosen site will be as conveniently near to a road as this idea suggests.

If paper is carried between two boards clipped together, even heavy rainfall will scarcely touch the outer edges of the paper. The paper should be about one inch smaller than the boards on all sides. Unused paper can be carried between the boards while the worked sheet is on the top surface clipped down for use.

One should perhaps add that the artist is advised to carry equipment for the medium which he has most recently used and with which he is reasonably familiar. In this way, he will be helped in overcoming the barrier which can occur between his vision and his hands.

WORKING CONDITIONS

Any attempt to find quiet, undisturbed working conditions is likely to prove un-

successful if one's equipment is set up too prominently, in a place which may attract spectators. To some artists this threat may not be a distraction, but to others it can damage a day's work. The advice, then, is not to be too conspicuous, and to show some skill in selecting a place to work. Unless one has experienced it, it is difficult to describe the sensation that the daylight is being slowly blotted out, the warmth of human bodies more apparent, and the general buzz of conversation, coming louder and closer.

There are exceptions to this situation. A completely sympathetic crowd of local people can be both charming and encouraging, adding atmosphere and a sense of occasion to what they regard as a perfectly normal but interesting occurrence – a painter working in their midst.

When one has plenty of time, one should beware the onset of a sense of well-being and peace with the world. The only way in which a painter can save his work from an indulgent sweetness is to walk away from the working site from time to time and return to it with renewed critical faculties. In these circumstances, it is sometimes a good idea to cut time down deliberately or take a harder medium for working.

The ground is as good a place as anywhere to rest board or canvas. If paper is being used, it should be clipped to a light board to defeat gale or wind buffeting, as even a light breeze will prove tiresome if this is not done. Drawing pins or thumb tacks should be avoided; they will get lost, become too firmly embedded in the board, or tear the paper. If the painter wishes to work on a surface which is absorbent but very flat, he should previously moisten and stretch the paper on a strong, rigid board, fastening the four edges of the paper to the board with some form of easily removed adhesive tape.

A well-tested and easy method of drawing out of doors if one cannot sit down, or if one wishes to walk about whilst drawing, is to make holes in the board at diagonally opposite corners and thread a string through them which can pass easily round the neck and under the collar. This is a surprisingly stable method of drawing.

To avoid glare in bright light when working on white paper, it is a good idea to get some sort of shadow, possibly one's own, on to the paper, until sufficient work has been done and sufficient paper covered to reduce the light reflected from it. Tinted spectacles can sometimes be useful under these conditions, but they should be removed from time to time as they will probably 'kill' highlights. It is possible that with the use of spectacles with polarized lenses an 'underwater' effect will be produced by the reduction of bright light and the unity of tone of the whole scene, and, though accidental, this could add an unanticipated new interest to the work.

Do not place the working box in direct sunlight if this can be avoided. Put a newspaper over the palette in the intervals of working. This is especially important in the case of watercolour and gouache. The use of colour in brilliant light is something which can only be learned by trial and error. Pigments are, after all, the same whether indoors or out, and it is only the dilution of colours and the selection from the palette which are affected by the change of light.

As an expedient during a working period, a piece of thin clean cloth can be laid across a wet painting in order to carry it about, even under the pressure of another board.

Another good method of surface protection is to lay grasses, flowers, or thin leaf sprays over the painted space – any light and small-stemmed plant available will do. This keeps the cover board away from the surface and interferes remarkably little

with the painting. It may even add, in a certain way, an extension of outdoor existence to the work. Thomas Hennel, when asked, in his Sussex cottage, where his studio was, replied, 'It's all around you'. This bringing of the location into studio working and thinking is not uncommon, in fact to some artists it is indispensable. The studio and the home literally become a cell of the landscape and are extended into it. Both the physical and intellectual aspects meet in the studio or go together out of doors.

3 · Working in or out of the studio; notes and references and their uses

The action of putting pigment on to canvas is only one part of an artist's work. There are always starting points for pictures around him and he must never lose sight of the fact that his job is to observe closely all the time; in other words, his mental store of pictures may be brimming over before he begins to edit them into a painting. To do this, he may like to collect reference notes and information bearing upon his ideas before working in the studio, or he may prefer to produce a finished work on location.

PAINTING ON LOCATION AND PAINTING FROM NOTES

John Nash and Edward Bawden are both Royal Academicians in Great Britain, both landscape painters, and roughly the same age. They have often painted together in the same place. It is interesting to see, therefore, the very different approaches adopted by these two artists in the collection of notes and sketches for paintings.

Edward Bawden always completes a painting on the site, no matter how un-pleasant the conditions may be or how long it may take. The concept will be seen, partly accepted, and recorded to a recognizable extent, then consciously and natur-ally developed into a personal and original work retaining most of the selected material, or, as mood and light changes, breaking away tangentially with some further concept loosely related to the original. The work will be carried home, very nearly dry (on semi-absorbent paper or board) and not touched again.

Each painting by Edward Bawden (pls 4, 5) makes a complete statement about its subject. These location-made landscape paintings form a fine-art cell within the wide range of his work; he is as well known in many circles as an illustrator and designer. Here we are only concerned with his work as a landscape painter.

John Nash, although occasionally completing a picture on location, usually prefers to draw out of doors for a considerable time with very great care. Page after page of his sketch books is filled with these drawings in watercolour, pencil, gouache or pen and ink. He reminds himself of the colours in a black and white drawing by written notes or an occasional smudge of watercolour. Later, in the studio, he edits these notes, exercising extreme care over their assembly and the relation of the items of design in the picture. He selects an atmosphere or time of day and, usually by means of squaring up his selected sketch, works gradually over his painting until the scheme is finished.

In plates 6 and 7 the pencil sketch of a landscape has been squared by diagonal and reticulated lines at regular intervals so that the sketch can be enlarged to any size while still preserving proportion. The use of these squares makes any deviation from the original impossible, thus all observation made on location is accurately used without loss or wastage of fact or design form. Irregularities which another artist might consider fortunate would be rejected as accidental by John Nash. If a small tree three fields away does not come out in the correct place in the larger painting, then the scheme is altered and reorganized until this has been put right.

The selection of material for reference is obviously very important, and here again, the approach will vary with the artist. At one extreme, there may be a faithful, accurately drawn note of the shapes and facts of the area; at the other there may be a search over the contours of a small part of the area, perhaps even a mere outline of the space between two shapes amongst the many items collected in the notes.

WORKING FROM PHOTOGRAPHS

It is inevitable that with the development of photography artists should have experimented with this as a means of storing references. The twentieth century has brought a glut of colour ciné (motion picture) films and colour transparencies in which anyone can record special occasions or remind himself of places of interest. This can never, of course, be the equivalent of a more personal statement in the form of a drawing or painting.

If a painter uses film in his material selection, black and white would probably serve him better than colour, because the reminder is then basic in shape and form; the colour can be retained in the mental image or written in note form. The colour image thus retained is far more personal than that recorded on a scientifically filtered film.

An experienced artist who uses film for reference will probably choose a tiny area of a photograph and magnify it, or use one of the two extremes of very pale or very contrasted prints or negative images. Any of these may be almost unrecognizable from the original but they can be of great interest and image value to the painter and may add something to his appreciation of the location. An ordinary photographic reproduction, on the other hand, will tend to be nothing but an irritation, asserting facts where one is trying to make poetry.

It is inadvisable, however, for a painter with little experience to arm himself with cameras and notebooks and try to record every aspect of a location. He will probably collect in a day sufficient material to keep another artist busy for a year, and will almost certainly lose his way in a plethora of facts and statements. He must, rather, look upon his chosen area as if he were never likely to see it again, thus imposing upon himself a strong discipline in the matter of selection and 'screening' of information.

It is interesting to speculate what would have been the effect on Constable's paintings if he had had access to a camera. It would certainly have been a tremendous loss to us had he not produced such a large number of quick-note sketches, many of which are to be seen in the Victoria and Albert Museum in London, and one of which is reproduced here (pl 1).

VIEWING NATURE SELECTIVELY

Some artists, when approaching landscape painting, believe that drawing and painting are indivisible. Constable's chalk and watercolour drawings are most interesting in this respect, especially the quickly executed wash drawings. In many of these there is the association of an almost map-like outer delineation of an area of colour and a firm descriptive drawing of growing forms. Here it would seem that Constable had seen the tree and cloud shapes clearly and had separated them in his mind, exercising his sense of draughtsmanship in stating what he wished to say about them, using line and paint to enclose the solid forms and foliage areas of the landscape. Later, these same tree forms may be used for a major painting produced in the studio. Take as an example the stem of the tree at the bottom left of his painting

The Cornfield, in the National Gallery, London. The tree is simple enough in silhouette, forming two linear edges confining the bulk of a column. Within this column are a great number of paint complications mostly consisting of layers of colour richly characterizing the line, and remarkably unlike the surrounding grasses which are given their own personality. In order to achieve this end, Constable has 'drawn' with narrow brushes the growth of flowering weeds and ripening wheat.

Another artist who exercised this very personal selection was Samuel Palmer, whose paintings in the Shoreham period of his work express so vividly the excitement felt in that first discovery of the land itself as a subject for painting – the scent of harvest and the warm light of a rising moon.

How much of Palmer's vision was the result of direct personal contact with the comfortable warm air of the Sussex harvest fields, and to what extent he became aware of the cool air of the approach of late evening can only be guessed at; our only witnesses are a few comments to friends and some recently discovered, but as yet unpublished, letters. It is, however, certain that he was deeply moved by these elements, and that only by half closing his eyes (or opening them very wide) against the full moon of midsummer, could he experience the shapes and evocative forms which appear in his paintings and drawings. As with Constable, it is important to realize that Palmer had no camera, and that only *his* eye could transmit through *his* hand the poetic reporting of a deep personal experience.

Although Palmer had no camera, he seems to have had a 'built-in' view-finder system and a method of selection of subject not dissimilar from the zoom lens of the television camera of the mid-twentieth century.

This principle may be recommended to the rather more experienced outdoors or location painter. Imagine for a moment that we are looking up a straight road with occasional traffic. At the end of the straight section there is a bridge across the road, above which are some trees and some farm apparatus. It is possible that these shapes in their setting above road level may be most interesting and invite closer inspection: vehicles prevent us from getting any closer. A narrowing of the vision on to the area in question by an aperture in a card or by screening with the hands will give greater emphasis to the shapes above the bridge.

Admittedly, it may be difficult to draw any notes in these conditions, but continued observation and checking of the values of the shapes and/or colours will not be too difficult, and at least some record may be made of the atmosphere and character of the place.

The 'zoom' principle may also be applied when the material is close at hand and when there is confusion and chaos in the field of vision which it would be helpful to reorganize or reduce. Here again, the reduced area of vision made possible by frame selection will prove useful, but this need not be an actual card with a cut-out viewing space. The selection may be made by the concentration of sight on to one small area to the exclusion – the very deliberate exclusion – of everything else.

If one closes one's eyes and then takes a swift glance at the prospect which is under study, this will give the impression of seeing it as for the first time. In this glance comparatively unimportant features of the place may stand out more clearly and assume new interest.

In an ideal situation, the direct painting of the image on location may be the most satisfactory method of working. Using good material in the selected medium, this could be the only opportunity of recording the happening. There should be no question of 'dashing off a sketch' in this instance – this is often a disguise for lazy working,

and the drawing may well become a 'complete' picture in its own right.

It is important to remember that a painter's notes form a statement about things he has seen and appreciated, and there is absolutely no obligation to make them intelligible to anyone else. This applies equally to all stages of the work in the studio, up to the finished painting. Both out of doors and in the studio, the artist must act as his own judge and adviser, and he will know sooner or later if his recording is genuine or insincere. If he is able to express honestly his own personal vision, this will show in the work by its direct human handling. Both over-confident and excessively cautious work can be unpleasant. A show of 'panache' in style can be irritating and will reveal without mercy any insincerity the painter may be trying to conceal.

This seems an appropriate place to mention that many keen amateurs spoil what might otherwise have been very pleasant work by their anxiety to please or impress someone else. Influenced by this desire they attempt to express things outside their experience, and sincerity is lost in the process.

The physical appearance of the work should not be awarded pride of place. A quality in the painting brought about by the disturbing or pleasing appearance of things will occur unconsciously. Perhaps the rule, if there is one, is to use paint in such a way that it will persuade the participating onlooker to accept the statement as it was intended, whether for violence or quietude, and to look beyond it to the real content of the picture.

4 · Figurative and non-figurative thought in landscape painting

Paintings are often referred to as figurative or non-figurative, as if there were some clear-cut dividing line between the two. Anyone who has made even a casual study of paintings of the last few decades must realize that this is not so, and that many paintings occupy a fringe position. However, to simplify our present thoughts on landscape painting, we will use the terms, figurative and non-figurative, bearing in mind that this is a very loose method of description.

An artist commencing a scheme of work must have been activated by some visible material, but whatever that material may be, it is the artist's reaction to it, and not the material itself, which determines the direction (i.e. figurative or non-figurative) which the work will take. Often a scheme of work begun in a figurative manner may gradually change through a period of working into something quite different.

MONDRIAN: FIGURATIVE TO NON-FIGURATIVE

Let us take one particularly clear illustration in the work of the painter Piet Mondrian. He was a figurative landscape painter, expressing with great skill for many years his appreciation of the land formation and natural growth which made up his environment. Gradually, however, his vision developed an increasing interest in the formal shape of things, and in the order of colour and pattern. This is a very brief compression of the most interesting story of one artist's development. We have a splendid illustration of the beginning of this development in his series of drawings of the great brick tower at Westkappelle on the Delta (pl 9). Here Mondrian states in pictures almost all that one could wish to know visually about this tower – its shape, colour, and the material in which it was constructed (the mellow, light-receiving natural brick of North Holland). He added to this information the vast area of sky in the low fen landscape, with very quick changes probably taking place every few minutes, all shown by the use of contrasting colours and a 'flicker' pattern.

Gradually in this series of drawings a point of no return is reached, after which the only possible comments on the tower shape and the light and air around it are formal ones. It is at this stage in the scheme of work that the development of the image becomes a matter of certain conviction, so that no other manner of presentation of the concept is possible without self-deceit. At a point in this sequence of action, the physical aspect of the tower very nearly, and then conclusively, ceases to exist in its original visual shape, that is, in the shape in which it would be seen by a general observer arriving on the island for the first time; yet the silhouette form of the tower standing against the sky is probably one of the principal contributing factors in the final, formal and designed vision which Mondrian produced from this landscape. Another painter facing this island tower might have seen a brick-like form standing on a horizontal area under a specific lighting.

Whatever the starting-point, an artist seeing for the first time a form or collection of forms which he feels he must draw or paint experiences tremendous excitement and exhilaration. Yet long and searching study, involving the making of many

drawings and paintings, may sometimes be necessary in order to organize this vision with which he has been, so to speak, bombarded. One picture out of this series of work may be brilliant, but this may be an isolated example. It is only by producing several paintings in the direction of thought suggested by the first that he will arrive at a positive, and perhaps poetic, statement of personal conviction. A plant in a field or even a hole in the ground may be his 'starting point', and in his work a completely unexpected series of forms and colours will appear as the exploitation and exploration of the subject proceeds.

TRANSFORMING SUBJECT MATERIAL

In Mondrian's Westkappelle paintings, we see the development of an artist. The reader will soon discover there are other more complex and deliberate ways of effecting this change of mind and eye from a figurative concept to a non-figurative one. The artist may select a small area of an original design and so reorganize and redesign its shapes and colours that the whole mood of the work changes and other values, such as colour conflicts and shape contacts, come to the fore. On the other hand, he may wish to blur the entire image, producing a new, neutral beginning from which to reconstruct a fresh design in a non-figurative discipline. He may literally cut his original design into reticulated or asymmetrical sections, reorganizing these on to a new surface or changing their order of movement, i.e. left to right, up and down, or in and out of the canvas area.

He may be equally interested in selecting only certain contour edges of the image, each capable of supporting areas of colour or space, and using these as units in making his design. To take a very simple example, let us assume that the painter is looking along a path bordered by trees. He may see this in a way which makes him want to interpret the full impact of the scene, the hard path, the growing trees, and the sense of air and light. He may, on the other hand, only want to record that edge of one tree which borders the space or volume associating it with the neighbouring tree, and to relate this to the horizontal surface of one section of the path in front of him. These two points fixed accurately on his canvas may, in fact, make a more profound statement about the prospect than the whole scene translated into imagery which could possibly, in trying to convey too much, become tedious and fail to produce the desired impact.

There is no reason why a person looking at a landscape before him should not see, and wish to show that he sees, a break-up of that vision into a topsy-turvy of form and colour made within a discipline of colour and technique. It need not appear on his canvas as an exact representation, such as might be achieved with a camera. We are concerned here rather with the breaking-up of an actual happening on the land into another order – a planned, designed order, the design being created by the painter as an association of intellectual and visual experience.

A painter may see at any time an item which he could take from its context and transpose into a new one to suit his own conviction. It may be an object before him on the ground or a natural growing form; his excitement and interest may be aroused by an engineering device or mechanism. The 'sky pattern' of the insulator in plate 10 is a typical example of this kind of opportunity in work. A painter could become more and more involved, with good effect, in the shapes of this unit on a railway siding.

There is a follow-through of design in the thin towers of lattice steel in plates 11 and 12, and their accompanying diagrams, 1 and 2. From this structure, a complete

scheme of work relating the construction to the rail track of the ground line could be evolved. Again, we should consider not one, but several paintings on the theme. One could fill a room with drawings, notes, structures and paintings in flat colour and line, of exceedingly accurate measurement, in observation of this topic.

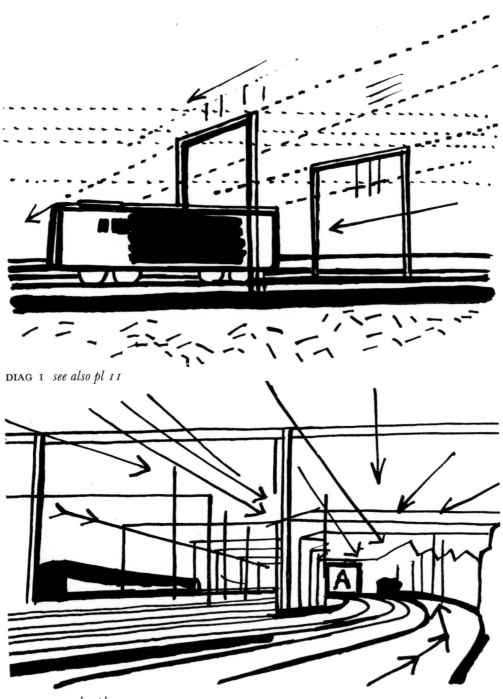

DIAG 1 *see also pl 11*

DIAG 2 *see also pl 12*

Mondrian's painting *The Dune* and Paul Nash's paintings of the Sussex marshes have a formality which makes direct use of the interruption of one shape by another. This is a more direct arrival at a result in which figurative shapes assume an order which tends to be non-figurative. These paintings have much in common with the formality of the background in a Gothic Book of Hours. It is also interesting to note the similarity of shapes in these Gothic rocks and in the rough, digger-shaped earth of a forest scraped into a motorway embankment (pls 13, 14 and 15).

PERSONAL CONVICTION

It is most important that a non-figurative design which has originated from a figurative version should not look back towards that origin. It is important that the title should not do so either, for the viewer or participant in the work should not be encouraged to associate the new painting with any previous idea. The origin is unimportant the moment re-thinking occurs. The association becomes journalistic in its 'chat-news' value and so detracts from the pure statement which the painting should be making. It is as absurd as to suggest that the architect who designed the flying buttresses and apsidal chapels at the east end of the cathedral of Notre Dame in Paris did so in order to make it look like a Gothic cathedral.

To see a realistic image in a non-figurative picture or shape is to negate the original thought, which may have developed slowly from completely non-representational material. For the 'pictures in the fire' images engendered from a purely abstract shape are surely accidental and meaningless, devaluating the content of the painting; they may even be regarded as a fault in the plan of work.

If an artist sees this severity and the disorientation of fact appearing in his painting, then he should be honest with himself and let it have its own way; conversely, if he is not really convinced, he should retain the personal, figurative approach, and exploit it until he is exhausted or has exhausted the concept. In the early part of the twentieth century it was unusual and progressive to be an 'abstract' or non-figurative painter, especially with regard to paintings of the land, whereas in the latter part of the century it is much more unusual and 'out on a limb' to be a figurative painter. Only the absolute conviction of the artist concerned, whatever his age or experience, can determine what course he adopts in his approach to his work.

10 Railway detail showing one major direction of vanishing line with vertical

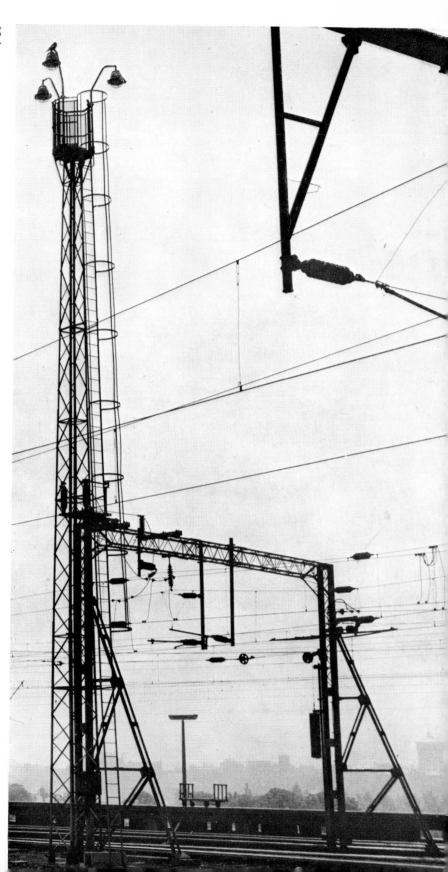

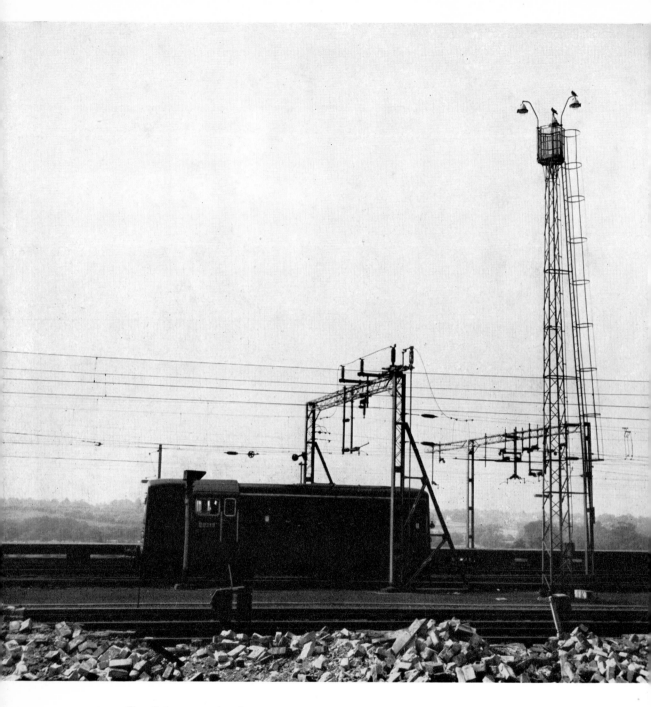

11 Parallel perspective forms

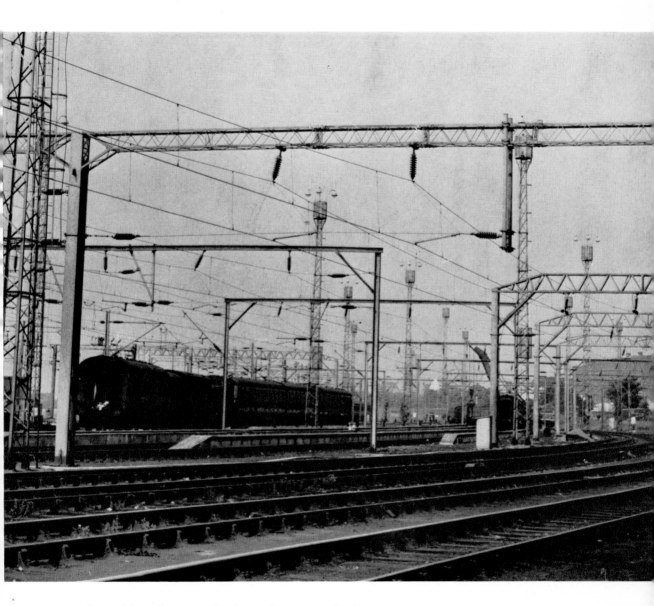

12 Repetition of rectangular form above curved rails

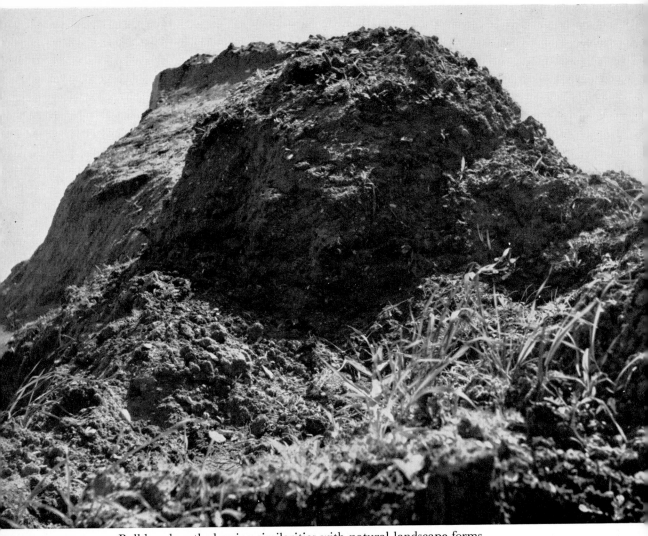

15 Bulldozed earth showing similarities with natural landscape forms

16 Repeating forms showin[
reflected images

17 Detail of 14 with accent on rectangular patterns in otherwise simple landscape surface

18 Flat landscape divided by strong vertical and horizontal lines

48

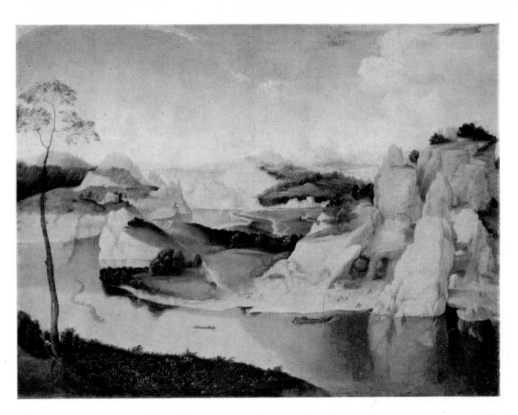

19 *A River among Mountains*, unknown Netherlandish painter

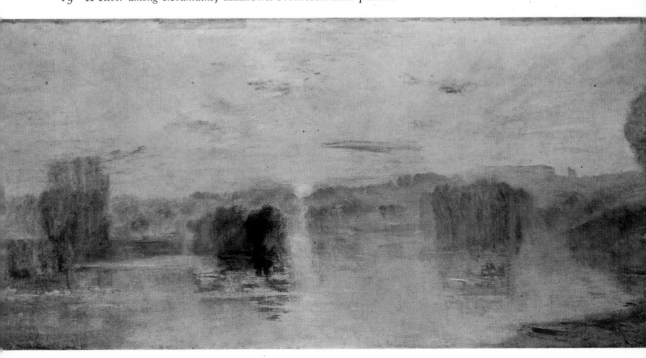

20 *Sun and Mist, Petworth Lake*, J. M. W. Turner

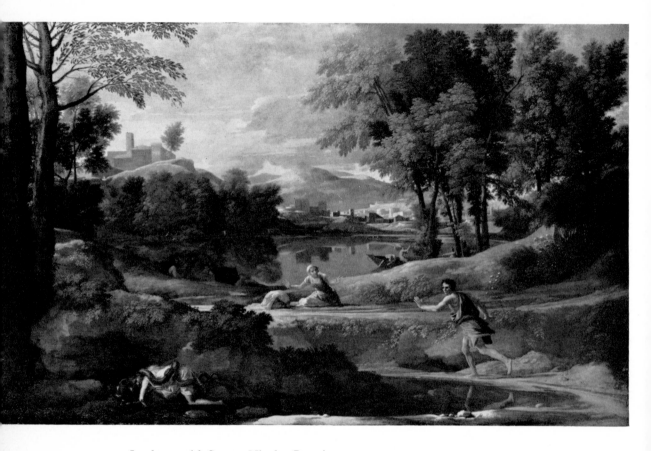

21　*Landscape with Serpent*, Nicolas Poussin

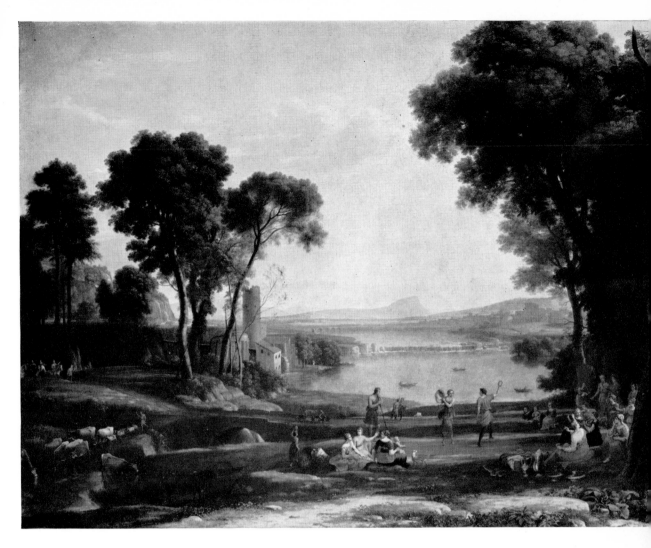

22 *Marriage of Isaac and Rebecca*, Claude

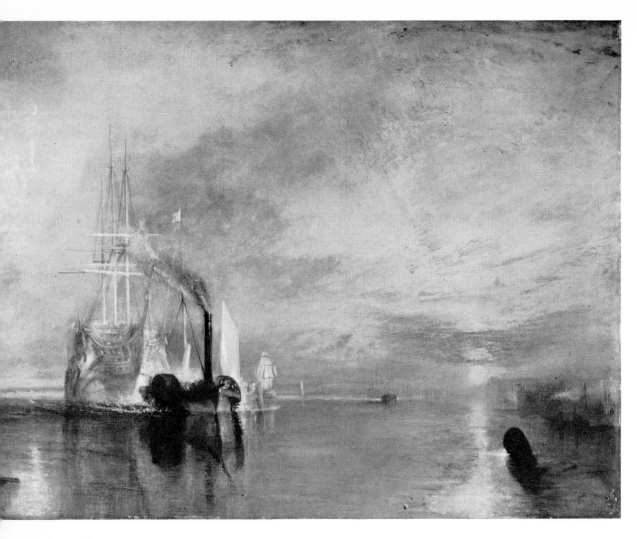

23 *The Fighting Téméraire*, J. M. W. Turner

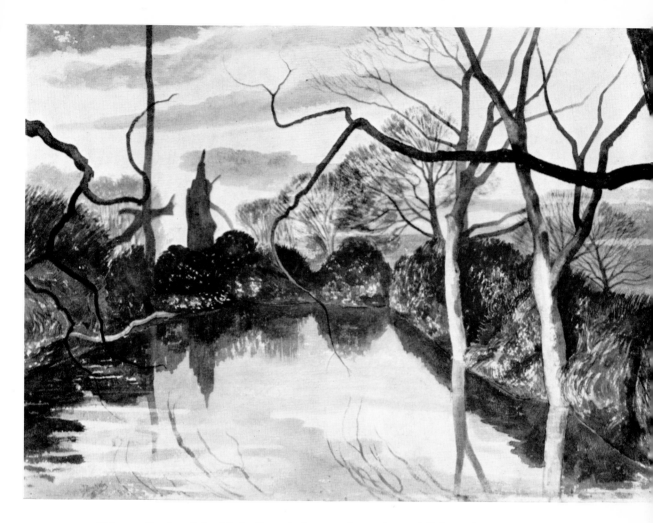

24 *February Evening*, John Nash. In pale browns, lavender and light yellow

25 Flat river valley pasture showing interruption by strong verticals

26 Bridge arches in summer with water level half that of winter level

27 Woodland showing division of area into clearly defined sections

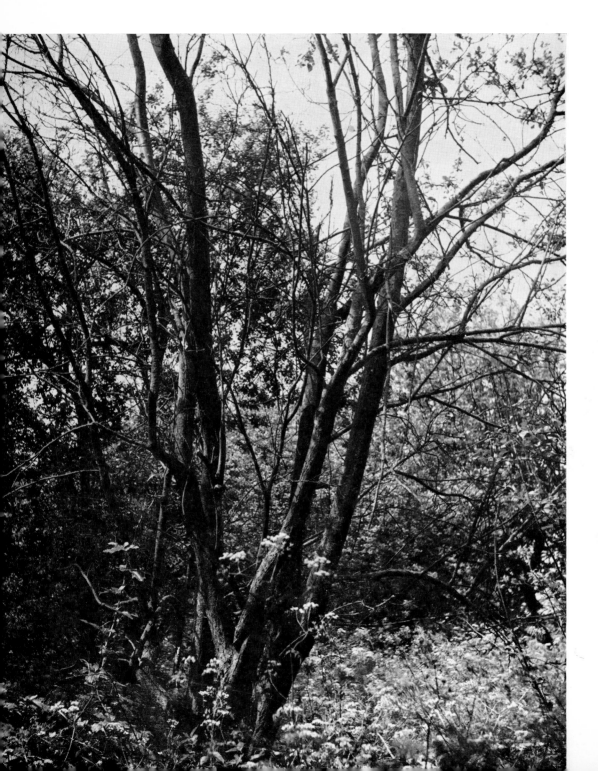

5 · Conscious and accidental use of perspective

The use of perspective may be a delight or an irritation according to the painter's temperament; there are painters who like to know the principles of perspective structure in the land around them, as a further dimension to what they already know. It would, however, be a pity if an understanding of the exact science of 'Italian' perspective were to become too strong a force. In the mind of some artists such knowledge can easily usurp the place which should be reserved for personal vision and interpretation. Conversely, the whole feeling of perspective may be the key point which sets an artist thinking and working in a personal way.

We are touching here upon the problem of painting what is 'known' as well as, or instead of, what is 'seen'. A newcomer to the business of drawing is pretty certain before long to say, 'How can I make an object go farther away?' or, 'How can I make the ground appear to lie level?' For an accurate representation of a specific place or series of objects this is a reasonable anxiety, but to the beginner who is painting the object which will not go away, it may be a blessing that he is not able to achieve his aim too easily. If, for example, the house which he wishes to put farther away is painted smaller than the house nearer to the observer, the desired effect of distance will be achieved. The debatable problem is that of the identity and value of the houses in the mind of the artist. If the smaller house is, though farther away, more important to the 'story' and plays a larger part in the life of the picture, then it could quite reasonably and logically be made larger in the picture. This is exactly what the thirteenth and fourteenth century book decorators did, and the same technique is also seen in Asiatic miniatures.

LIMITATIONS OF TRADITIONAL PERSPECTIVE

The general rules of perspective may be found in several text books, the names of which can be found in the bibliography. Accurate perspective measurement presumes that the eye of the viewer is looking in a fixed direction in a cone of sight (usually about 60°). This is clearly impracticable in much outdoor work, for it is natural both to move about within a limited space while making a drawing, and to look in several directions in quick succession. If we imagine an umpire at a tennis tournament, positioned by the net, we realize that his eyes move from side to side, following the ball in play, stopping suddenly and returning to the opposite side. The common centre of vision (in this instance the ball) moves in a curve over a central starting point (the net); each point along the curve will be the central vanishing point of the cone of sight of the spectator, and any one of these million points could be the central vanishing point of a landscape project. It is as well to realize that a rather similar movement in the happenings in a place may easily occur in our eyes, and a chosen point (perhaps a road) will be to the centre of the picture or left or right of centre as we move our eyes in a 'looking' or 'scanning' arc. This arc may be so shallow as to become a line from left to right or a vertical from top to bottom of the scene, like the sea horizon seen from a banking aeroplane.

This point is worthy of consideration in several respects: first, should a prospect be recorded from one single point or from several points? Second, why should we suppose that a picture will be more acceptable or satisfying when made from one small point, when the subject-matter in the scene and the live or inanimate objects around are just as exciting in movement when they pass one behind another – a pattern of fields or streets, for example, seen with the head held still, from the window of a train or car. Such aspects could be put into one painting or set of paintings. Third, as the slightest movement of the head in relaxation may alter the aspect of a place, it is inaccurate to say that the eye is focused on a given point for any length of time. A single line, paint area or edge will only be an approximation of the position in which the form or shape has been seen, a single instant recorded and realized as a part of the whole design.

USING PERSPECTIVE SELECTIVELY

We should not expect to be able to sit in a place from which we wish to draw or paint and find a ready-made layout of optically correct and easily acceptable perspective before us. Instead, there will often be, fortunately, a vast number of subsidiary planes, vanishing points and accidental happenings on or above the landscape. These will all tend to compete for pride of place. It would be better to select with skill and to retain only those basic elements of perspective which are really helpful in putting down the scene and conveying what we want to say about it.

Let us look at a simple piece of land and water, which, whether we like it or not, does obey certain laws of direct reflection and direction. In the multiple arches for the passage of flood water under a new road, a simple industrial type of bridging –

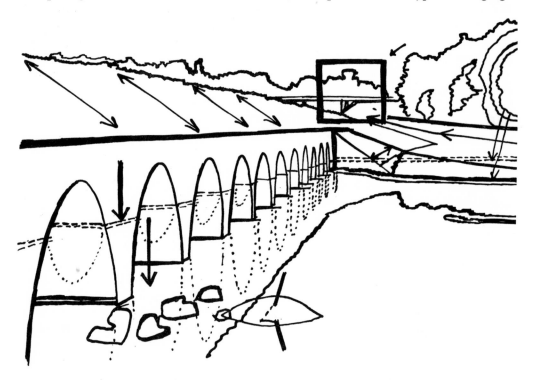

DIAG 3 *see also pl 16*

concrete cast arches filled over with earth – continues the line of the excavation quite naturally (pl 16 and diag 3). The repetition of the arch form and its reflection produces a pattern which may well be very rewarding to explore. At times of flood and higher river level the arches will be almost concealed, and a wide deep river will replace the shallow water. The progressive reduction in size of these arches is something which the eye can assess by careful observation, but it is important to understand that the whole of the complicated arch formation is clearly contained in area and volume by the overall shape of the concrete structure. If this is not accepted, the shapes within will be more difficult to define or record, should it be necessary to do this.

In passing, we may note that plate 11 and diagram 1 offer a good example of 'parallel' perspective (in which lines vanish parallel to the line from left to right of the viewer) as referred to in the serving-end view of a tennis court, whereas plate 12 and diagram 2 offer an angled prospect of the same setting. The pattern lines of each aspect are quite complete and both are really simple in their direction of line to a fixed point within the design area or to the right away outside it.

Briefly, then, if a casual study of perspective will help us to determine the depth and width of ground planes or angled planes in the landscape or built structures before us, it may be considered a good exercise. If, however, such a study is likely to interfere with the more personal point of view, and is merely a device to satisfy a whim for naturalism (or to please some person or persons outside the picture) then it is not a good exercise and should be avoided.

6 · Design and landscape

Under the broad heading of design, let us include not only the pattern shapes made by the various items of a landscape, but also the space relationships of one volume to another within the location, and the relative vigour of different features, due perhaps to a stronger colour or a more authoritative shape.

Design, though remarkably intuitive in some painters, necessitates hard looking and careful planning in others; both may arrive at a satisfactory conclusion by different routes.

The artist's attitude of mind will unconsciously determine his design of a landscape. One painter will be happy with a Classical design, balanced and stabilized by well-considered rhythms. Another will see a gentle undetermined flow in the same scene, and may allow an important part of the pattern to disappear below the working space, or move away out of the picture. Bonnard's paintings possess this characteristic to a marked degree.

Let us consider the work of a few other painters with special reference to the problem of design. This is not a study of their painting, but of their methods of designing landscape features and the resulting difference in their interpretations.

CÉZANNE, COROT, VAN GOGH

Compare, for example, a landscape by Cézanne with one by Corot. At the meeting place of two directly opposing forms – for example, a roof ridge and a vertical tree – Cézanne may bring the eye of the onlooker to the actual point of contact with such certainty that other relationships in colour vibration and optical excitement are not seen until later. Corot, on the other hand, allows the eyes to wander uninterrupted along the flow and swing of the shapes, stopping visual progress only to allow a light ephemeral area of more reticent forms to make their presence felt, and to sharpen awareness of them.

Van Gogh may be said to design by instinct, whether in the line of a wooden fence or the rough edge of a dusty road; we are aware of being led into the world of these objects, and of being left to like them or not once we are amongst them.

CLAUDE AND BRUEGEL

The observation of rules and formulae may be seen in the landscapes of both Poussin and Claude. A typical example of many such paintings is the picture in the National Gallery in London by Claude, which is a pure landscape 'scene' in the theatrical sense of the word. By the inclusion of a few well-behaved figures 'on stage', all obedient to the rhythm of the design, it justifies its title of *The Marriage of Isaac and Rebecca* (pl 22). The figures involved in the marriage are in poses which could well have occupied an empty stage before a single colour cycloramic dome. In Poussin's *Landscape with Serpent* in the National Gallery, London (pl 21), the superimposed layers of precise tree forms beneath organized sections of cloud shown in depth are all designed in relation to one another. In fact, the whole picture space is a complete

system of interlocking shapes.

An artist who enjoys the intricacy of pattern arrangement will be rewarded by a study of Bruegel the Elder's figurative landscape pictures. In his painting, *Winter*, the spaces and shapes formed between the huntsmen and hounds in the snow under thin trees are as carefully organized as the pages of a book, or the layout of a formal garden in a gentleman's estate of the same period.

TURNER

John Ruskin made diagrammatic analyses of some of Turner's paintings. He observed the retention of lines of pattern through the pictures, forming a sort of spatial arrangement of light and colour, sometimes contained only by a thread of cloud or a spot or splash in the water.

This different approach to design is seen in Turner's painting *The Fighting Téméraire* (pl 23), in the National Gallery, London, in which the old wooden battle-ship is being towed up river by a tug. This picture is an excellent example of the strength of a Romantic design. Not only is there romance in shape and colour, but striking juxtaposition of colours is also used as a language of expression in the painting. The pattern of the sky is an extreme example of planned alarm. Blue merges to a golden red and yellow which lead to a spectrum of vanishing colour in the remote areas of the sky. The curved lines of the tug and the reflections in the sea follow a long fixed inward line, like that of a wide coiled spring. Here again, we have a stage, with a sea and a vast backdrop of sky, with shapes which we recognize as ships on the water; but the theatrical effect is achieved by those inward curving lines of irregular radius which depart very surely from the Classical origins of the horizontal sea and the dominant characters to left and right.

It is interesting to see form associated with design in the painting, also by Turner, *Sun and Mist, Petworth Lake*, in the Tate Gallery, London (pl 20). Here, the original and the reflection vary considerably. Allowing for the break-up of water and light, a crossing wind and other hazards, there is little relationship between fact and reflection. This painting also shows another aspect of design, used by Turner and some of his contemporaries, which has been used many times since. This is a strongly-coloured tree of outstanding tone in the near centre of the picture, a further pursuance of the artist's earlier technique of using a simple tower seen in a remote valley as a motif and starting point for a picture in watercolour.

There is a skilfully designed landscape by a sixteenth-century Dutch painter, in the National Gallery, London, which is entitled *A River among Mountains* (pl 19). With a sense of anonymity, this picture describes a river winding among clearly-drawn rocky cliffs; these are topped with green and black fir trees silhouetted against a sky which could be charted like a sea-bed. Nothing is left to chance in this carefully-designed picture, and yet we are not unduly conscious of the imposition of a plan upon our eyes when we enter the world of the painting.

Now let us look at a picture in which we can trace both the Classical and Romantic lines of thought. It is a painting by John Nash (pl 24), in which the careful observation of the design of previous sketches referred to in Chapter 3, has produced a work which is part Classical and part Romantic in mood. Here we can also see the interruption of one form by another, notably the movement of the water horizontally, set against the shape of the broken tree which interrupts, like an arrow, the clean purity of the sky. These motifs tend to produce an atmosphere of tranquillity created through disturbance.

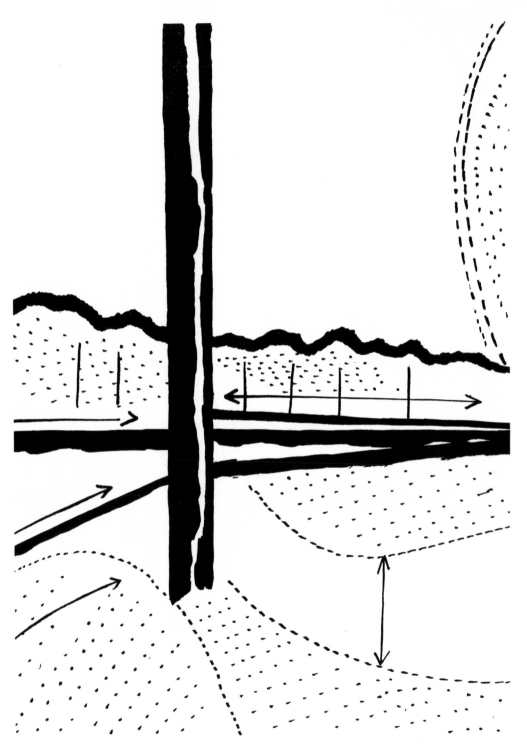

DIAG 4 *see also pl 18*

We can go on location without putting down this book, by looking at several photographs of land which have the characteristics we need to study. These are not to be looked at as photographs of landscape, but rather as a walk into the open to select items there, to see how such items already interrelate or could be made to do so, to note the movement of one form against another, and the impact of a vertical against a horizontal.

In plate 18 we can see this very clearly, and diagram 4, corresponding to this photograph, emphasizes the point. The prominent tree makes at least two, if not three, very precise divisions of pattern, and it is interesting to look from these to plate 25 where the same theme is elaborated, rather as a musical variation is written around a few original notes. The box in diagram 5 should not be confused with this comment; it shows a possible new picture referred to elsewhere.

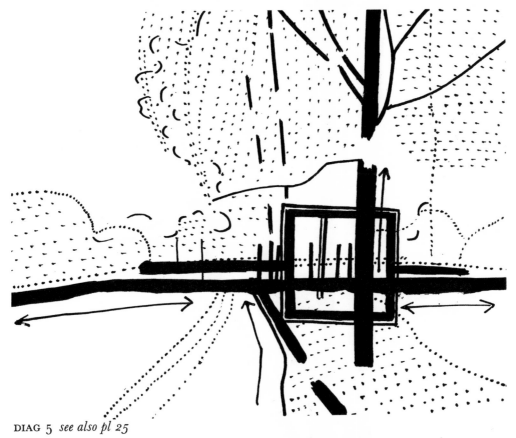

DIAG 5 *see also pl 25*

Movement of forms and patterns can be seen if we look at plate 27 and diagram 6, in which the pattern areas are indicated by lines and dots. One runs across the lower half of the space, interrupted from the bottom right-hand corner by a curve and a rectangular pale zone; in the actual place, these are brighter leaves and flowers. Above the central band and to the left is another section of darker tone formed by new foliage on a tree. Over all this one can see a grid of tree stems and springing branches which bind the design from top to bottom, forming a dominating V in the centre and bounded by tree shapes on either side.

DIAG 6 *see also pl 27*

Look now at the new bridge under construction, giving access to a scoured bank of excavated woodland (pl 14). In the 'zone' of the bridge there are many complexities of structure, both in scaffolding and permanent material on the roadway. It is important to feel that all these articulations and tube forms of the work of building are associated with and enclosed by an area of vision bounded by the bridge. There is a strong feeling of interruption here as the road and building forms impact upon the roughened land and bulldozer tracks made in a very different material, earth. All the separate items of the bridge, each capable of re-order and application into a single and effective piece of design for our use, must be subservient to the vertical direction of the steel scaffold and the inward direction of the road level, parapet and scaffold platforms. These seem to drive into the earth bank and become buried within it.

Notice also on this photograph the steep direction, emphasized by ruts of tractors and sun shadow, of the bank ahead and the downward curve of similar vehicle tracks from the point of impact in diagram 7 of the bridge parapet. It is interesting to see how the circular disc in the lower foreground punctuates this change of direction in design.

The repetitive and enclosing feeling of the vertical poles in plate 17 and the trees in the cut meadow in plate 25 is repeated in the overhead electric cables in plate 12, which decrease to create pattern and a sense of tightening. There is also in this photograph, and in plate 10, an example of clear, hard, engineered lines against a pure surface (in this case the sky), giving a number of sometimes repeated, sometimes original silhouettes and shapes in formal order.

Irregularity in the countryside can be found in a very small area of land formation; for example, a close view of ploughed land (pl 32) can be seen as an air view of a series of mountain valleys. If we return to the little painting by the unknown Dutch artist (pl 19), we can see this clearly. The winding valley certainly suggests a wide area of land with distant trees and hills, but the rock formation reflected in the water is painted as a much narrower and more intimate gully. The deep green patches of moss are on smooth rock surface similar to the scooped surfaces on the excavated 15-foot mound of clay in plate 15 and diagram 8.

A DESCRIBED SUBJECT

Design and scale value will vary according to the content of a painting. To illustrate this, let us take a look at a prospect of which there is neither photograph nor painting, assembling the image mentally, and analysing what we see as we read the description.

We are sitting in a neat garden divided into planted flower beds cut out of brilliant grass across the lower border of the picture; the plants are strong in colour, a mixture of begonias and low-growing roses. Beyond the small lawns is a white wood fence which is partly concealed by an encroaching but trimmed hedge. Immediately above the hedge is a row of chimneys and rooftop ridges, a small clock tower and several parapet shapes from the tops of the houses in the street beneath. It will be realized that the street is lower than the chimneys by the height of the houses, and the chimneys are level with our eyes. Above the town is a band of green fields, woodland, and some well-defined areas of cultivated land. There is an occasional patch of brighter colour from new crop or dead grass between scattered trees, walls and hedges. Above this is a further, quite complicated band of gently moving contours dominated by one or two larger, steeper shapes of two or three layers of blue-grey and dark coffee-coloured mountains. Over all this are two or three layers of grey

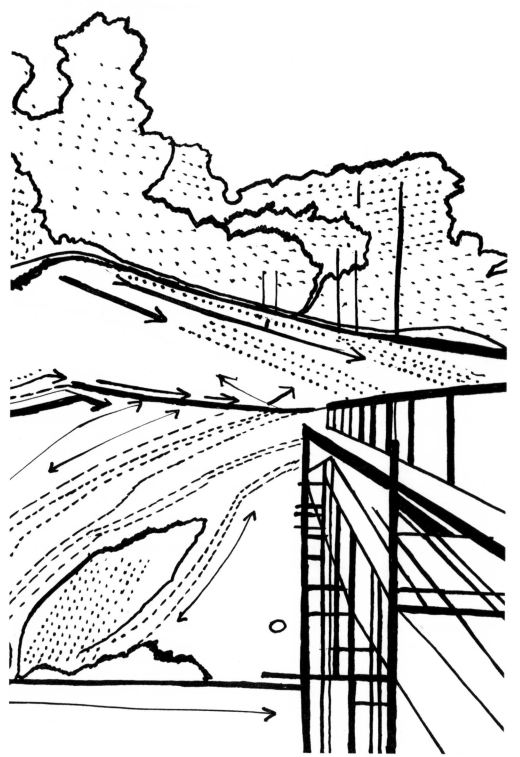

DIAG 7 *see also pl 14*

DIAG 8 *see also pl 15*

and amber-tinted clouds broken into infinity in places by a piercing of the cloud formations through which the sky can be seen as through a cavity.

In the line of small chimney pots and gables, upper windows and dormers are several square openings of frameless windows which make other voids in the centre of the scene before us, and which are strangely akin to the hole in the cloud already described. These take our eyes right into the centre of the location in a line leading directly from us, contrasting remarkably with the irregular but horizontal band which passes across the image and into which the neat elements of the town are packed.

PICTORIAL ALTERNATIVES

Any section of this band could be cut down and reorganized as a picture. One could gather a key for a colour scheme from any selected piece of the whole, however small it might be. For example, a light blue appearing on the painted stone frame of a dormer window may be the exact blue of that section of the broken sky which suggests infinity in the interval between moving cloud forms. Naturally, the similarity could be only short-lived, as the cloud gap might be closed at any second by the action of the wind, but the comparison would have been made, and the colour sympathy would remain in the painted window colour. The physical fact of the unmeasurable difference in scale here, i.e. the quarter of a mile gap in the sky and the 24-inch window is one of the principal interests of this setting.

67

The problem of using this prospect as a painting would be to decide whether to include all four bands of design, or an association of three, or merely one, allowing the unwanted area to pass from our minds for the time being. Whatever plan we decide to use, it should ensure satisfaction to the eye in whichever direction it travels over the painting. To achieve this, it is possible to link such isolated shapes as the square window with other angular shapes in the picture. For example, the curved edges of a flower bed leading to the uprights of the fence could carry our attention across to the window and surrounding chimney pots quite naturally and easily.

Look for a moment at a painting (pl 4) in which Edward Bawden illustrates this point to some extent. Here the wall on the left leads up to the front of the house, and then across the window frames down to the garden below. It will be noticed that the sky contour has much in common with the up-and-down, rather square edges of the shrubs and plants in the foreground.

Before we discard the village image, let us consider an association of colour and design here. These are closely tied up in the silhouette shapes; for example, a dull purple or pale scarlet flower in the garden may be the complementary colour to the deep honey and green of the fields, or, above that, a tone of one facet of the mountains. The paler tones of the leaves of flowers may suggest a passage of simple, plain colour exactly like that of one of the mountain contours against the sky. The reflected light of the sun behind us from a window of one of the houses may be that same white light which appears on the forward surface of a large cloud, or it may reflect a very different section of sky, again from behind us, which changes rapidly from blue, through green to yellow. All these possibilities may occur above the begonias and roses whose colour and tone will vary according to the master light from sun and cloud.

A personal discipline may allow an artist to paint 'all the scene' in, say, tones of blue, red, green or grey only. This method of working, although it would give immediate value to the design, could tend to reduce the scale of each section of the pattern.

It will be seen that this exercise can best be tested by persuading a number of artists to visit the garden (we hope separately) and produce either a formal picture of the whole setting or selected areas; one artist might paint a dormer window with a potted plant, and the hills behind reflected in the glass; another, a single begonia and a mountain; a third, a green lawn punctuated by flower beds, with the town and the mountains reduced to a mere line of colour above it.

THREE-DIMENSIONAL PAINTING

We should by now have a pretty firmly established picture in our minds of the described scene (which does, in fact, exist) and it would be most interesting to see each reader's reaction, in image form, to the notes. These may vary from lines on a flat surface to a form of three-dimensional handling of the subject, still within the terms of painting.

The use of surfaces projecting or receding from the general flat plane was used to some extent by sixteenth- and seventeenth-century architect-designers, and the Victorians returned to this tactile approach, in a rather different way, when they produced their modelled pictures, slightly recessed, of sitting rooms, shops and sea-scapes. In the latter, a distant ship might be pressed deep into the wood, plaster or gesso, and half the hull of a near ship would be modelled in the round, to project right out of the main plane of the design.

This solid form of picture design, widely used between 1850 and 1900, has influenced artists in the latter part of the twentieth century. Some are returning to three-dimensional painting, in an age when decoration in that sense is no longer in general use. This also spotlights the close association evident today between painting and sculpture which, in terms of landscape perception, makes good sense considering the three-dimensional and spatial quality of our environment.

We have seen, then, that the essential factors in design may be treated in a Romantic or a Classical way. The personal attitude of the painter, dictated by such influences as his way of life and its comparative freedom or restriction, will determine which approach he will use. The eye and mind will work together in accepting a motif or unit, thus formulating an idea, and eventually a picture.

7 · Seasons and elements; reflection and the theatrical element in landscape painting

It is a common fallacy that painting landscape is an entirely pleasant affair, a means of escape from everyday activities; and implicit in this belief is the even greater fallacy that nature turns a perpetually benign eye on the artist.

The painter of landscape should be prepared for a great deal of discomfort, both physical and mental. This is, after all, an art form concerned with the basic material of the earth, sometimes modified or re-formed by man, and with natural conditions and phenomena which are still liable to rapid change even in our age of advanced scientific knowledge.

We will have to allow for sudden changes in temperature, for wind and rain which may in turn become hurricane or flood, for frost and snow, for changes in light effects by sun and moon and the passage of cloud formations, for the intrusion of animals, the irritation of insects, and for the change in the landscape brought about by natural growth during the period of carrying out a scheme of work.

There must inevitably be a struggle for priority between the artist and the elements. If either becomes supreme master there will probably be a falsification or inaccuracy of statement in the result. A happy medium can be attained between total acceptance of dictation by the elements and internal discipline on the part of the painter, who will wish to assert his interpretation of the happenings in view. The middle course, so to speak, which will be most likely to produce a satisfactory answer to the problem will be that which is limited by acceptance of existing conditions on the one hand and the artist's personal image on the other.

The principal disturbing factors are brought about by seasonal changes. Some of these are too obvious to mention, but the painter cannot afford to ignore any of them.

THE CHANGING LANDSCAPE

Say, for example, that a field is ploughed in December or March and for a time remains an area of deep brown furrows. Harrowing follows and the surface becomes flat and smooth. A few weeks after sowing this surface will be pale green with young corn. At this stage a flood or another natural hazard may cause the setting to revert to the flat level earth of the previous month. This is bad luck for the farmer, but may prove to be good luck for the artist who can produce a pictorial landscape or an abstract image from this change, possibly gaining some reward when the farmer is suffering misfortune and loss. This illustrates the tangential contact the painter has with the land, as distinct from that of the man earning his living from the crop produced by it.

Another natural change which provides material for the artist is the rise and fall of tide up and down the wall of a harbour and in and out of a river, filling and emptying a 'tide lake' (pl 31 and diag 10). Here the ground plane line is raised and lowered in a most spectacular and natural manner (pl 30 and diag 9).

Man-made changes occur if there is an engineering project in progress which

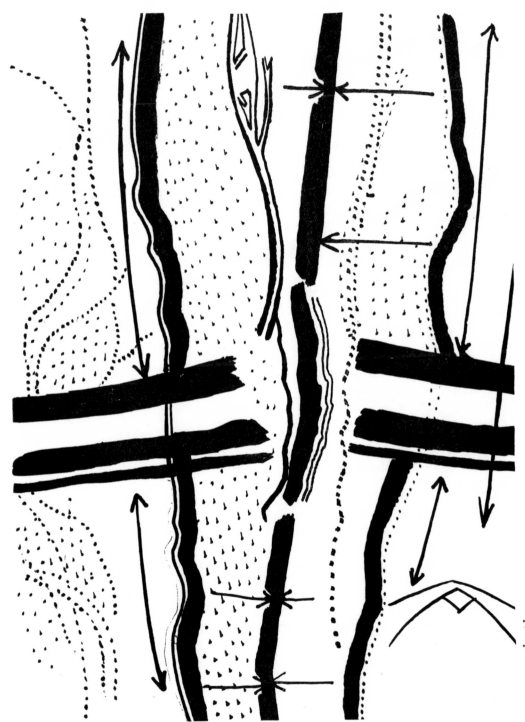

DIAG 9 *see also pl 30*

DIAG 10 *see also pl 31*

entails the raising of earth mounds or deep excavation, such as in quarrying, mineral extraction or bulldozing of road embankments. These temporary or semi-permanent changes in the landscape form will influence a painter's outlook in locational working.

The play of light on the surfaces of buildings and the resulting changes in quality of texture in those surfaces can be a source of new ideas to the painter. For example, a flint and flush work wall (that is, a design of pinnacles in stone and flint set in panels on the wall) on a fifteenth-century gatehouse changes colour and mood completely during the course of a day, or during rain followed or preceded by sunshine. Each facet of purple, black or bluish flint absorbs and reflects the light of the sky and clouds, deepening in colour and intensity. The stone darkens and becomes greener, in summer a pale green, in winter a yellowish grey tint. The million facets on the wall are rock-like and react to light in the same manner as the sheer wall of a granite cliff or ravine; water can pour down the surface from the gutters and gargoyles as a waterfall comes to life after a heavy storm in the mountains.

Similarly, glass or bright metal walling will reflect the sky and clouds and achieve a transparency and a pattern. Glass walling in particular will naturally reflect every minute nuance in sky conditions.

Let us consider the field in question in more detail. Suppose it is allowed to grow to full corn height and ripen in the early summer; the whole area will be from three to four feet higher than before. Allowing for the fact that there may be neighbouring

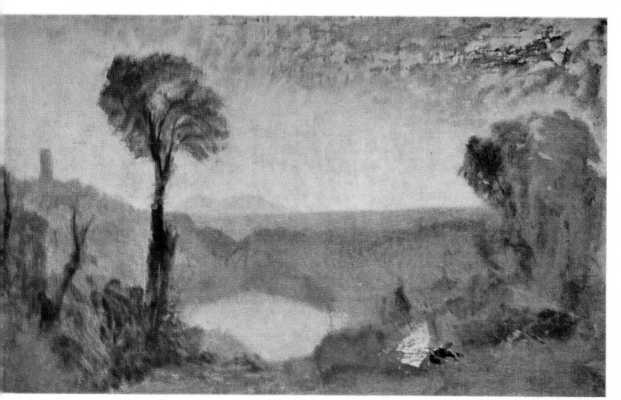

28 *Lake Nemi*, J. M. W. Turner

29 Summer growth on an otherwise plain surface

31

32 Dug earth form

33 *Cader Idris*, Richard Wilson

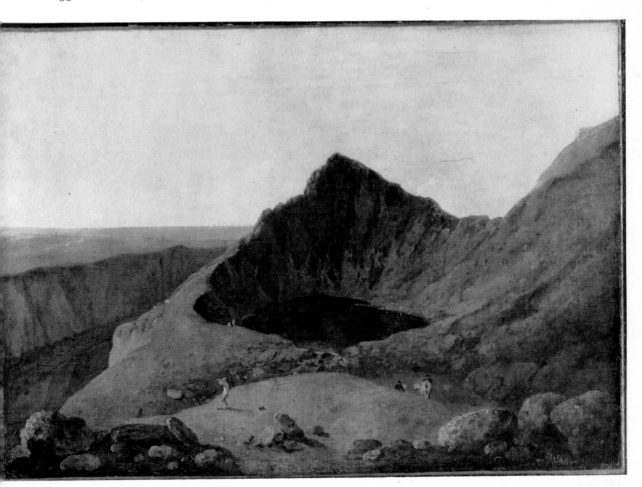

34 *Night of the Deluge*, J. M. W. Turner

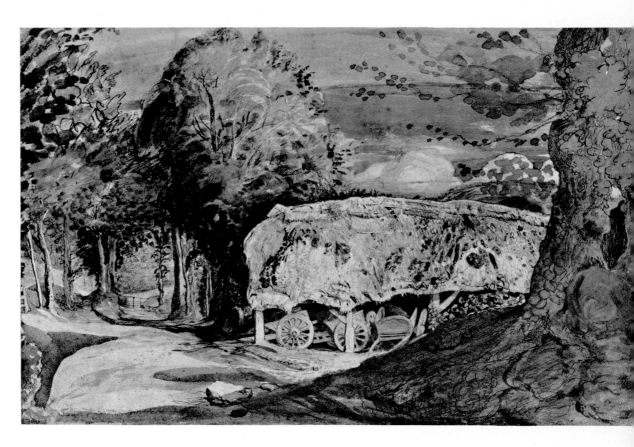

35 *Lane at Shoreham*, Samuel Palmer. Warm colours: orange, brown, light green and blues

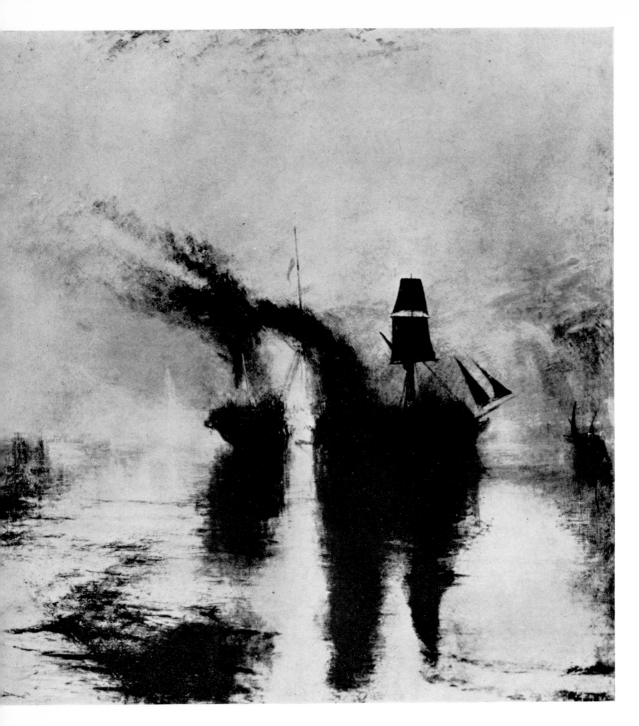

36 *Burial at Sea*, J. M. W. Turner

areas of cultivated land or scrub which develop long, flowering grasses during the same seasonal period, it will be realized that the whole landscape surface will have risen. Trees will appear to have shortened, hedges and bushes to grow out of the corn. When related to other ground in the area, this temporary ground level will show sudden or gradual rise and fall, giving an entirely new visual measurement of the earth surfaces in the landscape.

Drawings and paintings of this type of changing scene made, if this is possible, over a period of two months would be fascinating for several reasons – certainly on account of their clearly defined differences in colour, possibly their different tactile quality, and especially in the effect of lowered or raised ground. For 'ground' we should read any lower visual surface, as this may well be the upper layer of a thousand particles which form a ground – for example, the ears of a crop of corn, the flower heads and buds of an area of poppies, field daisies, flax, or sunflowers.

The structural make-up of this surface will also influence vision. If it is composed of light, airy material, such as flowering grass, flax or oats, then it should be painted in such a way as to exploit this quality. If the growth is stemmed and branching as in an umbelliferous type of flower head, such as cow parsley, then two growth layers will be found with an air interval in between enclosing the stems. From place to place, the lower (actual earth) level may be seen through intervals in the upper flowering level, as the earth or sea is seen through a gap in a cloud layer from several thousand feet in the air.

A false level may also occur from isolated bands of fog or river mist. This should be drawn with great accuracy, showing exactly where the mist line intersects larger natural or man-made forms, as it is in these intersections that much of the pattern, both figurative and abstract, will be found. The transection of a growing form or constructed object by such a line is immediately new and interesting, proposing as it does new aspects of familiar forms normally seen in other contours. (It is interesting to note that here the problems of the landscape painter infringe on those of the dress designer, where cut edges and the hems of clothing help to give a new interest and character to the wearer.) This new contour, seen as a ground plan in perspective, will show the hollowing and curving of the surface of partly-covered objects to describe something new in the picture area under review. The false level may be that made by snow retained in hilly country in spring when the air is cold enough at a few thousand feet to keep the ice and snow, but is warm enough to encourage growth down in the valley. The line may sometimes be completely level for several miles.

These things add excitement and interest to the picture and suggest corollary themes which were not obvious in the original concept of the landscape. They have a lasting property which is more personal than the plain recording of direct vision.

REFLECTIONS

To simulate a reflected shape in a formal way is relatively easy, if one obeys the rules of perspective in drawing. This will result in the appearance of shapes of reflected form or areas of reflected colour which are in themselves independent of the original. The most obvious illustration here is the 'make-and-break' shape of a reflected light in moving water, seen from above to form a broad design, or from a lower position to form a smaller, active part of a major picture design. A good example of this is *Burial at Sea* by Turner (pl 36).

In the late nineteenth and early twentieth centuries, Monet and James McNeill

Whistler used this physically intangible but natural form in many of their paintings of the Seine and Thames. Piet Mondrian, in the figurative period of his work, made use of a similar planned disorder in both reflection and sky to such effect that the interval between the making and breaking of the image disappears almost entirely.

We are faced with two types of reflected image for our acceptance or rejection; first, there is the broken image, reflected on a moving surface, with a strong pattern and arrangement of shapes. Here, the original may be a round, square or multi-faceted form, but there will be practically no easily recognizable repetition of it in reflection if movement is taking place on the surface, as in *Petworth Lake* or *Lake Nemi* by Turner, in the National Gallery, London (pls 20, 28).

Each area should be so clearly thought out that it could be taken from its context and made the principal theme of a new picture.

The second type of image is that of a scientifically measurable reproduction of the original in a still surface. We should see and think beneath and beyond the reflection to appreciate this phenomenon to the full, to make a complete mental reconstruction in the surface of the forms existing in the reflection. The full exercise of formal perspective here entails vanishing points, accidental vanishing points, and horizon line or lines. There will be the optical diminishing of a distant piece of the reflected form so that the surfaces are measurable in the reflected image (pl 36). If this mental reconstruction is not carried through, the result will be a corresponding lack of conviction in the artist's interpretation of the scene. He should feel that there is also a surface facing downwards or away from him, and that the full content matter is there although it cannot be seen. These problems are much the same whether the subject is a mountain reflected in a lake or a bush reflected in a puddle.

The Richard Wilson painting of *Cader Idris* (pl 33), in the Tate Gallery, London, has unusual qualities which add to the anomalies sometimes produced by perspective and reflection. One is acutely conscious of the levels in this painting. The level of the mountain lake and that of the more distant flat valley are clearly different, and we get the feeling that we have come down a flight of steps or a rocky walk amongst flat boulders.

The levels in Edward Bawden's picture (pl 4), also in the Tate Gallery, London, are very clear, and for the same reason we feel in sympathy with them. We can walk from the high road, drop into the garden, and drop again down to the lower garden, and possibly into the bottom of the valley. There is a sense of hazard and physical effort required in making this journey; and this feeling is equally strong in the Wilson painting, possibly because of the intensely clear way in which everything is painted, giving the land an almost surrealist quality. Here, on the mountain, it seems quite possible that we could be caught in a suddenly descending mist after sundown, or twist an ankle between sharp boulders in the descent. We are not immediately aware of the devices which have created this illusion of insecurity and physical danger, or of the skill which has enabled Wilson to form the sharp peaks and edges of rock round the lake. Hazard is the keynote in these surfaces.

J. M. W. Turner's *The Night of the Deluge* (pl 34), in the Tate Gallery, London, is a picture which, without the movement of wind and the imminent arrival of a great storm, would not exist: that is, without the event of the storm used by Turner to create the atmosphere of the painting. This is only the literary aspect of Turner's absorption with colour, dragging tones and reflected light in the air. This painting is as much an emotional–intellectual occasion as a piece of operatic singing or spoken drama, and demands similar sensibility in our reactions to it. Here, we can

either respond to the turbulence and natural upheaval or we can follow through the more intellectual plan by which the thought process of the work has been organized. We may see the masses of colour disturbance above and below, and expect and require little other than these factors to alert our appreciation of good and bad in the picture.

Despite every effort to deny the theatrical impact, it is unlikely that many people can regard this picture purely as a plan of considered colour and ignore the power of the natural energies which are inherent in its concept. This painting demands an acceptance of physical discomfort as much as it disturbs the eye and mind with colour associations which arouse our intellectual awareness.

'TEXTURE' AND DETAIL

Some artists with little experience feel that paint areas must always have 'textured' surfaces. This is a mistake, for plain surfaces or areas of plain colour retain their character and are frequently appreciated for their own sake; their appeal is much the same as that of most solid shapes or untouched surfaces. The seasonal development in the land makes the greatest changes when these surfaces are in contact with growing things. For example, plate 29 shows a weather-boarded building which, because of the spring growth of cow parsley, has developed into a wide pattern area. Here, the direction of growth and juxtaposition of spaces by the flower heads move contrary to the direction of the tarred boarding. Similarly, the rising of the cow parsley and long nettles in plate 27 shows an expansion of the ground level to a height of four or five feet by which a volume is formed. An air space is occupied in which the small flower heads and a skeleton of stems and subsidiary branches of these stems shape the outer contour of a season's growth. The whole space between the vertical and the horizontal levels of the flowers has become a new, temporary and measurable bulk. It can also be seen how the actual air depth in the near distance is made solid by the close contact of the stems and trunks of slight trees, each imposing a distance upon its neighbour, making the space between them more important than they are in themselves. Some very strong lines can still be followed in the springing branches moving to the edges of the right area.

A further example of growing volume can be seen in plates 26 and 31. In plate 31 there has been new growth after a seasonal fall in the level of water of a stream. New leaves are already filling in flat areas of mud and shallow water; in plate 26 a similar situation occurs. Here, the strong angular and curved motif of the bridge stabilizes the setting, and one's attention is drawn to the light, airy quality of the new spring foliage and of the first reeds of the year in the recently storm-flooded river.

This particular landscape would be much harder and more linear in a winter photograph. It is interesting to note that at that time of year, the sun would be behind the trees just above or below the level of the parapet in the late evening; the brick face would be in shadow and the reeds missing; the river level for winter would be around the area of the tops of the reeds, producing quite a different image for painting. Quickly moving water would alter the emotional aspect of the foreground, and the bare trees and sky would occupy the upper area more completely, with greater incidental interest on the same skeleton of tree trunks and parapet.

SKIES

The formal layout of a cloudy sky, without land, as a skyscape, is as much a whole

episode as a part of the main scene. Where a reflection occurs, it is more than ever a major item, and may become the principal factor in the visual side of a painting.

The completely plain, cloudless sky, a cycloramic void in tones of graduated colour according to sun glare, warm earth vibrations, or the glow off a water surface, becomes a design shape which in some way encloses the land. The void becomes an optical force whether there is land or not. We have an area of toned canvas with no suspicion of form in it. The term 'optical force' is intended to suggest a tension in the act of looking and a compulsion to look in a certain direction – in this instance, deep into the land.

In a hilly country in which cloud shapes move rapidly over the brow of a hill or mountain in quick succession, at an angle away from that of the land, the cloud forms will be seen to be quite independent from and pulling away from the land mass, thus producing an optical force away from the picture. With inexperienced handling, this can be disastrously disappointing to the painter. There are, of course, artists who would welcome the deliberate contra-suggestion of wind and land. They make powerful partners and need some controlling, even if one is prepared for them to form the whole basis of the work, whether seen realistically or not; but if they are planned merely as a section of a painting, they could easily demand excessive attention and draw interest away from other aspects of the work. The reorganizing of cloud masses into a drawn or painted structure from previously assembled notes can be a rewarding exercise to carry out in the studio.

Cloud shapes which flow out of the viewed area and come towards the eye with some vigour can damage or destroy the original image. This is because a slightly hypnotic effect is produced by the continued 'coming on' of the clouds, especially if the point of origin is unseen behind a mountain shape. This alarming and relentless movement may well be the greater interest for artists who are setting out to use the feeling of moving forward which is experienced here.

J. M. W. Turner, from the time of his earliest watercolour sketches, made sky shapes the principal object of his interest, in fact, they were often the excuse for whole paintings. In such pictures as *Hero and Leander,* in the National Gallery, London, and *Hannibal crossing the Alps,* in the Tate Gallery, London, he puts much greater emphasis on these forms than upon any other matter in the design. The drama of both occasions is created by the movement of clouds – in *Hero and Leander,* the great thunder clouds of the sea storm over the swimmer, and in *Hannibal* the sudden drifting away of rain clouds reveals a penetrating sun over the elephants.

It is interesting to compare the cloud shapes in Claude's *Marriage of Isaac and Rebecca,* which we have discussed in an earlier chapter, with those of Constable, Corot or Delacroix. The flat, cut-out sections of cloud in Claude's picture interlock like pieces of a jigsaw puzzle. The nineteenth-century painters referred to above all use the actual cloud shapes as 'solids' in their pictures. If we imagine for a moment such cloud shapes in, say, bright green or blue-black with purple shadows, they become, in fact, vast overhanging solids looming over the land beneath them.

A painter experimenting with cloud shapes should take care not to reduce them to an uninteresting mechanical formula, but neither must he allow them to assume an unwanted authority.

We saw earlier that much of what we call landscape is man-made or man-influenced. In the sky there is one particular feature of twentieth-century living which is artificially produced and which creates a major disturbance. This is the passage of vapour trails from aircraft; these can produce a disorder or a classic

84

symmetry, a single linear stream of colour and an atmospheric disturbance receptive to sunrise and sunset lighting. As they are equally subject to slow winds and gales, these trails will often cover the sky quickly and must be taken into account as part of the 360° arc of sight. It is interesting and rewarding to note how often vapour trails flow in a curve or series of curves which fit remarkably into the general scheme of pattern and design in the land curve or smaller ground formation.

Besides these varied weather conditions and certain physical changes of a landscape, we have the constant factor of the timelessness of the land, sky, sun, moon, smoke, living things and dying things. The sun and moon painted by an artist of the 1960s are the same sun and moon as in a Turner painting or above the château in a French Book of Hours. Whether the landscape is natural or industrial, it remains an inexhaustible source of copy for the artist.

8 · Use of colour

There is no reason why we should not paint a landscape image entirely in black and white, leaving the colour to be determined by the viewer. The range of colours in a painting may be so wide as to produce a total spectrum, but such a painting viewed with the eyes nearly closed, or at dusk, will accept a much more restricted colour range, with many tones in between the two principal colours.

A basic human love of colour causes most painters to use coloured pigment. An artist who is accustomed to using a particular range of colour will tend to see things around him in that range. Colour to the less experienced may be subconsciously dictated by familiar sights in the home or neighbourhood. This familiarity, if put to good use, sometimes produces the 'natural' painter, whose observation is of such a high standard that he cannot help giving an accurate, or at least sympathetic, colour interpretation of what he has seen. Some artists feel the need to struggle against this skill, and have difficulty in colour discipline as a result of this too-good, 'pick-up' eye. Others can harness and moderate the visual image and go ahead unhindered.

THE PERCEPTION OF COLOUR

Most of us are able to retain colour mentally to a certain extent, but the memory will most likely reflect colours which we have encountered during the day, and reproduce them with a personal stamp, because of the 'pool' or filter of tone through which we see all colour.

To some people, each day of the week has its own colour, and this is the same kind of colour association through which the painter sees his own environment.

Diagram 11 shows two rectangles, one surrounded by a tone area, the other by a white area. Look closely at each in turn and consider a separate colour for each. You should be able to imagine your chosen colour filling the rectangle at which you are looking. You will find this easier with the one which has a tone behind it, as the eyes will be made to focus on a shape in a quiet background. You may find yourself supplying a colour for the background as well.

As an example of colour choice, let us suppose that we are looking at a black chalk drawing of a harbour wall, against which an incoming tide is moving. The sea zone terminates in a horizon, above which are cloud shapes. If we know of such a place, we will tend to see the black drawing in terms of remembered colour. We may supply, for example, a red sky or a silver sky, a white sea or a rich purple sea, according to the degree to which our memory has been aroused by the black drawing.

The perception of colour is, of course, an immensely personal matter. Tests prove that tones are not easily defined in cases of slight colour blindness, and that the same colours are recognized in different ways by different people. We have only to look at a bright setting in the sunlight, covering first the left, then the right eye, to realize that each eye sees the colours differently; the eye which is in use pools the colour into a limited range of tones, but to the newly uncovered eye it is, for a few moments, much purer and clearer.

DIAG II

Some people will tell us that they only dream in monochrome, and others always in colour. This colour may be controlled, that is to say, the colours of the dream may be in tones of rich orange or deep blue, or in a scheme of pearly brilliance.

The proximity of one colour to another often causes disagreement among painters, so that, for example, turquoise will be regarded as either green or blue according to the amount of yellow or blue light admitted to it and the type of artificial light directed on to the area.

The physical nature of surfaces seen will also release different colour responses in different painters, and these various responses will obviously be important in determining the character of the completed works.

PAINTING WITH A LIMITED PALETTE

We have already seen that landscape pictures, whether figurative or not, may be painted in a controlled colour scheme, according to the artist's preference. There is another approach to this matter which is an excellent discipline for the more experienced painter. The picture may be produced entirely in three colours, perhaps deep Indian red, blue and a warm grey. Under these conditions, all the tones of the picture will have to be produced from these three colours, and their juxtaposition will greatly effect the final appearance of the work. For example, if a prominent feature is a vertical wall with a hard, clear surface moving strongly into the picture, this may be seen as a reddish grey wall or a blue-purple wall held in position by clear Indian red, pure blue or reddish grey areas around it. Thus the wall, as it moves across the picture, becomes a clear-cut image amongst other shapes and colours. On the other hand, should the wall be seen as a paler grey zone in the design, held by a red above or a blue below, it will seem to be light in weight and more direct in its movement through the area of the painting.

This limitation of palette may become a necessity if a painting is made in a

location where only a few colours are available. A key colour used in such conditions may establish itself as a principal fact in the character of the painting, and can often transform it from the 'ordinary' into something more important. The fact that the colour range is small and 'unnaturalistic' will forbid any appearance of tints and tones unrelated to the environment and disassociated from the pattern of the picture.

METHODS OF COLOUR SELECTION

Here are three basic approaches to the problem of colour selection:

First, the precise accuracy of the carefully reproduced colour, mixed on a palette and judged as applied to canvas, paper, or whatever the surface may be.

Second, the heightened key of colour in which similarity of tone is observed, but in which the pitch of the colour is deliberately altered, i.e. brighter reds for yellows, deep blue for light green, or orange for black, and so on.

Third, the reorganization of colour in the picture or series of pictures, along with a similar redistribution of the shapes. In this case, there is no reason why any of the colours in the picture should be representationally correct, but they should be realistically correct in the most precise sense of the term; that is, they should promote the intended emotion and be physically and intellectually expressive in spite of their unexpectedness. Colour should not be predictable or necessarily acceptable to anyone, and the painter should feel no obligation to explain his choice of colour scheme; so long as it expresses his own personal feeling about the place and the *genius loci* it may be considered genuine.

Bibliography

Baldass, Ludwig, *Giorgione*, Thames & Hudson, London, 1965

Ballinger, Harry R., *Painting Landscapes*, Watson-Guptill, NY, 1965

Ballinger, Harry R., *Painting Sea and Shore*, Watson-Guptill, NY, 1966

Baskett, John, *Constable Oil Sketches*, Watson-Guptill, NY, 1966; Barrie and Rockliff, London, 1966

Brandt, Rex, *Watercolor Landscape*, Reinhold, NY, 1963

Butlin, Martin, *Turner Watercolours*, Watson-Guptill, NY, 1965; Barrie and Rockliff, London, 1963

Carlson, John F., *Carlson's Guide to Landscape Painting*, Sterling, NY, 1958

Clark, Kenneth, *Landscape into Art*, John Murray, London, 1952

Cohen, William, *Chinese Painting*, Phaidon, London, 1948

Constable, John, *Memoirs*, ed. Leslie, Phaidon, London 1961

Crespelle, Jean Paul, *The Fauves*, Oldham Press, London, 1963

Exner, Walter, *Hiroshige*, Methuen, London, 1961

Gore, Frederick, *Painting: some basic principles*, Studio Vista, London, 1965; Reinhold, NY, 1965

Grigson, Geoffrey, *Samuel Palmer. The Visionary Years*, Routledge and Kegan Paul, London, 1947

Grossman, F., *Bruegel. The Paintings*, Phaidon, London, 1955

Kautzky, Ted, *Painting Trees and Landscapes in Watercolor*, Reinhold, NY, 1952

Kautzky, Ted, *Ways with Watercolor*, Reinhold, NY, 1963

Lamb, Lynton, *Preparation for Painting*, Oxford University Press, London, 1954

Norton, Dora, *Perspective*, Oaktree Press, London, 1965; Sterling, NY, 1964

Olsen, Herb, *Herb Olsen's Guide to Watercolour Landscape*, Reinhold, NY, 1965

Patterson, Henry, and Gerring, Ray, *Exploring with Paint*, Studio Vista, London, 1966

Pitz, Henry C., *Drawing Outdoors*, Watson-Guptill, NY, 1965

Pitz, Henry C., *Drawing Trees*, Watson-Guptill, NY, 1956

Postels, Theodore de, *Fundamentals of Perspective*, Chapman & Hall, London, 1951

Renoir, Jean, *Renoir, my Father*, Collins, London, 1963

Rothenstein, John, and Butlin, Martin, *J. M. Turner*, Heinemann, London, 1964

Russell Flint, Francis, *Water Colour Out of Doors*, Studio Vista, London, 1958

Seuphor, Michel, *Piet Mondrian*, Thames & Hudson, London, 1957

Sierp, Alan F., *Applied Perspective*, Angus & Robertson, London, 1959

Taubes, Frederic, *The Technique of Landscape Painting*, Watson-Guptill, NY, 1966

Watson, Ernest W., *Composition in Landscape and Still Life*, Watson-Guptill, NY, 1959

Watson, Ernest W., *How to Use Creative Perspective*, Watson-Guptill, NY, 1955

Woodward, Stanley, *Marine Painting in Oil and Watercolour*, Watson-Guptill, NY, 1967

Index

Nash, Paul 8, 40
National Gallery 11, 13, 35, 60–1, 82, 84
non-figurative painting 37–40
 as a gradual process 37–9
 its independence from figurative origin
 40

oil paint 14
 on paper 27–8
opaque watercolour, *see* gouache
optical force 84

painting from notes and sketches 11–12,
 33–4
 from photographs 34
 from verbal description 65–8
 on location 32–4
 equipment 28–30
 materials 14–28
palette 29
Palmer, Samuel 35
paper, carrying of 30
 handling of 26
 moisture absorbency of 16
 rolled, flattening of 26
 selection of 16, 25–7
 sizing in 26
 storage of 26
 testing of 16, 27
 unsuitability of 25–6
 types of: brown (wrapping) 25
 'canvas' 27
 cartridge 16, 25
 hand-made (hot-pressed and 'not')
 25–6
 Ingres 16
 Japanese 27
 'laid' 25
 lithographic (offset) 25
 Michallet 16
 'parchment' 25
 Strathmore 16
 'wove' 25
pattern in painting 37–40, 59, 61, 63–4, 68
pencils 25, 29
perception of colour 86–7

perspective 57–9
 in relation to personal vision 57
 limitations of 57–8
 selective use of 58–9
photographs, use of 34, 63–4
pigment changes in drying 27
pigments 14–15
Pollaiuolo, Pietro 11
Poussin, Nicolas 60
protection of unfinished work, 26, 31–2
 of pencil work 29

reflections 81–4
Romantic design, *see* design
Rousseau, Henri, 'Le Douanier' 12
Ruskin, John 61

seasonal changes in the landscape 7–8,
 70–2, 81, 83
 as challenge to the artist 70
selection principle in working from notes
 33–4
 in working on location 35, 67–8
selective viewing of landscape 33–6
 in formalist painting 38
sizing in paper 26
sketch books 29
sky as part of landscape 84
solvents 29
sunlight, effect of 31, 72

Tate Gallery 61, 82, 84
technical fluency as danger to integrity 13
texture of landscape, changes in 72–3, 83
three-dimensional painting 68–9
Turner, J. M. W. 8, 12, 61, 81–2, 84–5

Van Gogh, Vincent 60
Victoria and Albert Museum 34

watercolour 15, 25
Whistler, James McNeill 81–2
Wilson, Richard 82
working conditions 30–32, 70

'zoom' principle in selection of subject 35